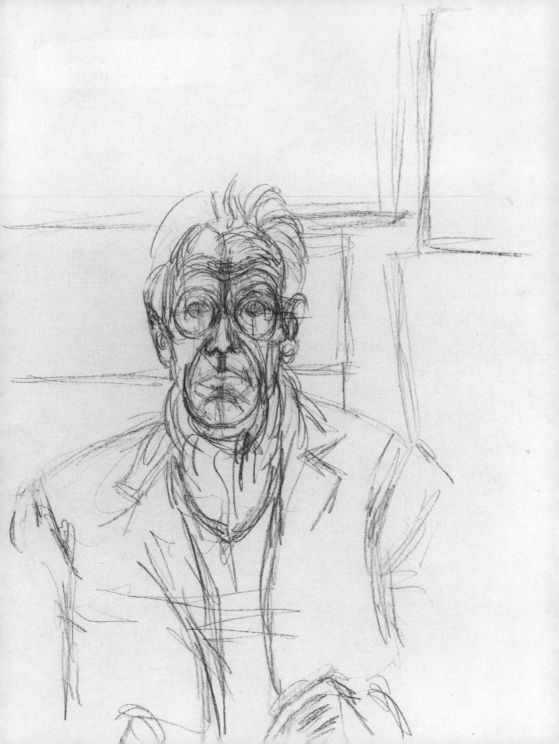

JACQUES **DUPIN**

GIACOMETTI THREE ESSAYS

TRANSLATED BY JOHN ASHBERY

AND BRIAN EVENSON

BLACK SQUARE EDITIONS

HAMMER BOOKS NEW YORK

"Texts for an Approach" was first published in *Alberto Giacometti* (Maeght Éditeur, 1962) and republished in 1991 by Fourbis. "Impossible Reality" was first published in 1978 as the preface of a catalogue of a retrospective exhibition at Fondation Maeght, Saint-Paul de Vence. "A Writing Without End" was first published as the introduction to Alberto Giacometti's *Écrits* (Hermann, 1990). All three texts were published together in *Alberto Giacometti* by Jacques Dupin (Farrago, 1999).

Published in the United States by Black Square Editions, an imprint of Hammer Books, 130 West 24th Street, #5A, New York, NY 10011. U.K. offices: Four Walls Eight Windows / Turnaround, Unit 3, Olympia Trading Estate, Coburg Road, Wood Green, London N22 6TZ, England.

ISBN 0-9712485-3-2 First printing February 2003 All rights reserved

Library of Congress Cataloging-in-Publication information on file

This publication was made possible by the generous support of William G. and Joan B. Spears through Adopt-a-Book, a program administered by the Society for French American Cultural Services and Educational Aid.

The publisher wishes to thank Andrew Joron and Rose Vekony for their invaluable assistance in the editorial preparation of the present volume.

Frontispiece: Alberto Giacometti, *Self-portrait*. Pencil on paper, 42 × 32.2 cm.

Designed by Quemadura Printed in Canada by Kromar Printing Ltd.

TEXTS FOR AN APPROACH

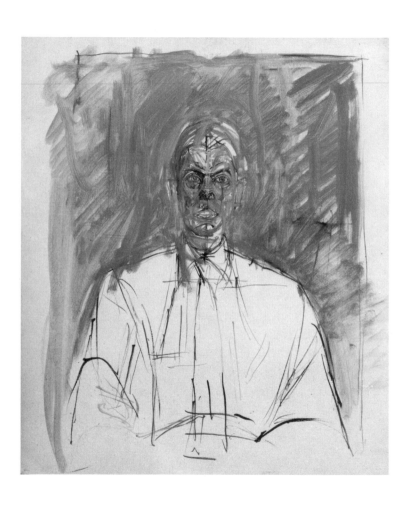

1

Each work by Giacometti is the looming of a separate presence which reveals itself as a totality, or rather as the movement and the demands of a totality that awaits only our consent in order to be finished, accomplished—and called into question again. It may initiate us, but it also deprives us at the same time of our instruments of analysis and investigation, our questionnaire and our references. It discourages and ruins any gradual accession to knowledge of itself. It subjugates us at once by a kind of silent commotion which keeps us, but at a distance, in the grip of a gaze whose intensity is almost unbearable. If we can bear this look, if we accept the fascination it exerts, we ourselves become the locus of an acute questioning which obtains no other reply than the same interrogative, fascinated space opening up inside us. Through this movement of our being, this unconditional acceptance, we supply a meaning, but an absolute one, to the sculptor's activity; an outlet, but a fictive one, for his torment; a new object for his thirst to destroy. Through this act we accept to be changed into Giacometti's people, that is, figures of petrified incompletion; and we reopen for him the space which he again closes around us. From this work which renders such a transmutation not only necessary but possible, I can speak only as

Portrait of Jacques Dupin 1965 Oil on canvas 65 × 54 cm

a stranger, or at most as an accomplice with a faulty memory, a victim determined to keep up the misunderstanding.

And in fact the written word, condemned to deviousness, tries desperately to find the sudden approach again and is tormented by nostalgia for it. It tries to recreate the strangely active space of that work by attacking it from several sides, as one reconstitutes illusively the unity of a sculpture by multiplying one's vantage points. In its fragmentary pursuit it takes the same path a dozen times, while certain areas remain inexplicably barred to it. Too close to its object, it petrifies and consumes it; too far away, it loses its way and disintegrates in a maze of expectancy that has no beginning. Entangled in lacunae and contradictions, it leaves behind nothing but the muddled traces of an approach, scattered fragments, the least significant debris, spared by the flames, of an imaginary edifice which had to be abandoned.

2

It begins with the painful awareness of solitude, a desire to communicate with others, with the world, and anguish before the recognized impossibility of that communication. No matter how near he may be, how affectionate, how understanding, that other person can do nothing for me and I can do nothing

for him: we speak but do not hear each other; we touch without knowing each other. Or *almost*. But that almost is not enough, or is just enough to enrage the man who refuses to give up. A gulf separates us, a vacuum we secrete, a distance which our lucidity and our efforts to narrow it only make more painful. This distance, this vacuum which turns Diego into a stranger, which turns a chair into an incomprehensible, uncertain, dangerous object ... Face to face with this vertigo and this fear, Giacometti seizes a pencil, a brush, a handful of clay ... By *copying* what he sees, as his father taught him when he was a boy, he hopes to give consistency to the reality which eludes him, to see it, hold on to it, and hence to affirm himself in its presence. And as he copies it he advances toward the most exact portrayal of what he sees, but also toward awareness of the absolute impossibility of this attempt. The affective ordeal becomes identified with his experience of the perception which objectifies the inner drama. His procedure turns into a stubborn, furious pursuit of a prey which escapes him or of a shadow which he rejects. The closer he comes to the *truth* of the object, the more he deepens the gulf which separates him from it, the more he feels and communicates the acute feelings of his difference and his separation.

Have others succeeded in finding what he searches for in vain? In museums Giacometti hunts that truth, which is not realism but *likeness*, with the same

avidity. By turns he imagines that he has captured it in Venice with Tintoretto, in Padua with Giotto, in the Cimabues of Assisi, in Corot, in Cézanne. As he draws he falls in love; he copies "almost everything that has been created since the beginning of time." In Chaldea, Fayum, Byzantium, the Egyptians—especially the Egyptians—he imagines he has really found that unexpected likeness. But no matter how promising the trail is, the reality of a tree or of three girls walking ahead of him dissolves what was once again only the marvelous illusion of art. It is impossible to render, hence to know, reality; but the impossibility is fascinating and its temptation irresistible. Solitude closes in once more on man, but man's fate is to strive without respite and without hope, to open a breach in the wall of his prison. Through series of trials, failures, leaps ahead which are but the varied moments of a single experience, Giacometti approaches the inaccessible goal he assigned himself, and at the same time expresses the lyric investigation of a conscience tortured by the impossibility of communication. This expression of a private drama, determining an aesthetic style, insures his success with the public, while the advance of his art on the level on which he himself places it, that of realistic representation, leaves his admirers indifferent. Yet these two aspects of his experience are inseparable, and the fertile ambiguity of his work is the direct result of his fierce attachment to the subject.

From this standpoint, Giacometti is today as far removed from abstract painters as from figurative artists. For the latter, with rare exceptions, reality is only a point of departure, a springboard. They use it and play upon it; it presents them with no problem; still less does it confront them with its refusal. Giacometti, on the other hand, does not interpret reality deliberately; instead he strives to copy what he sees, simply, "stupidly," desperately. He plants himself in front of the model and works from life; he copies in a way that no one today dares to. His attitude is in absolute contradiction to all the tendencies and experiments of his time and the theories which justify them. He is alone in his century and against everyone, clinging to his obsession, against the current in spite of himself. He opposes everyone and yet no one is indignant at this intransigent, insolent behavior. In museums and private collections his works are placed near paintings and sculptures whose meaning and basis they contradict, whose very meaning as works of art they contest. How is it that the scandal has not yet broken out? Why has no one rid our cities of these men who walk against time, of this woman who stands like a silent challenge, of the many insistent haunted faces who emerge from the walls like proofs of those depths whose name we no longer have the right to pronounce? How is it that we tolerate this single, inexorable question, we who open the door only to answers?

3

In his studio, Giacometti seizes a handful of earth, mounts it on an armature and kneads it for a few seconds. A standing woman has emerged, living and indomitable, fortifying and satisfying my expectation. But the moment I dream of taking her away with me, Giacometti's work begins, that work which has no beginning continues. Abrupt and infinite birth, dizzying spectacle in whose presence I can hardly banish the strange feeling of being personally involved. Agility and sureness of those hands, running from the top to the base and from the base to the top, as though over a wild keyboard. Each isolated gesture here seems meaningless. Yet their rapid succession and the ease of their sequence gives the impression of a mysterious necessity. And this stratagem, this ballet, this struggle goes on for nights and for months on end. Furious and futile activity, necessary and tedious, in which the positive act and the destructive act join and become indistinguishable, weaving the same creative duration without beginning or end, from which the standing woman draws her authority, her grace and her separateness.

Abrupt and infinite birth and, rather than a finished work, a continual work. The essential purpose of the sculptor's gestures seems to be to keep up a

dialogue between the figure and himself, to perpetuate a living exchange, to unite them both in an intimacy and an expectation which little by little would take the place of that communication whose impossibility fascinates him. As I look at them, the figure and the hand begin to form a single being, at once self-contained and in perpetual gestation, a being which never ceases to live and yet is always beginning to live, to perpetuate itself and to become visible.

With any other artist it would be theoretically possible to determine exactly what a single touch of color or a stroke of the chisel brings to the work in progress, for each gesture adds itself to the preceding one, modifying the part and the whole, causing the work to advance toward its end (the end proposed or supposed from the beginning). Giacometti's gesture is of another sort. His repeating, his re-examining contradict the deforming brutality of each particular intervention. To make and unmake incessantly is to diminish, to deaden each gesture, to drown it gently in sequence and number, as the sea absorbs its waves. Thus the figure I am watching him model seems to me at first indifferent to the cruel attentions the sculptor inflicts on her. Kneaded with an imperious, violent touch, it would seem that so fragile an apparition must inevitably return to the chaos from which it came. Yet it resists. The destructive assaults which it endures modify it only imperceptibly. Their repetition im-

munizes and protects it, allowing it to live its life on the sidelines. It accepts them and grows accustomed to them; soon it can no longer do without this rough rude caress. In fact its autonomy and its identity spring out of this torture, *on condition that it be limitless.* From the exact distance which it needs in order to subjugate us, it calls with all its desire for this punishment which fashions it and strips it bare, which detaches it and strengthens it, to surge at each moment out of the void. Immediately this standing woman erects before my eyes her fierce, mysterious presence. With the promptness of lightning she strikes me without giving herself. But at the same time, because she yields nothing of herself—nothing but her totality—she does not drain my desire and her refusals paradoxically develop an enduring power of attraction. I obtain all of her at first glance—that is, her distant, separate being—and losing her so quickly makes her newly desirable to me, with a desire no sooner fulfilled than renewed. Simultaneously she attracts me, pinions me and keeps me at a distance. Because she is both the looming of a presence and the inexhaustible possibility of communication by default, she advances on me and recoils at the same moment, or rather outside of time. There is in her structure as well as in her unfurled power a resolved conflict which remains conflict. That is, a tension which submits and does not destroy itself. An integrity which reestablishes itself incessantly in the perpetual motion of the opening and the

destruction which it provokes. Every work of Giacometti, like this figure, draws its sovereign affirmation from the interrogative space which it renders visible, from its refusal, its withdrawal, from that menacing and nourishing lived period of time which makes and unmakes it.

4

There is, or at least there was, an instinct of cruelty in Giacometti, a need for destruction which closely conditioned his creative activity. From earliest childhood the obsession of a sexual murder provoked and directed certain imaginary performances, like the cruel, darkly romantic reverie he recounts in *Hier, sables mouvants*. He was fascinated by accounts of battles. The spectacle of violence intrigued and terrified him. Formerly, with chance acquaintances or friends, especially women, he could not refrain from imagining how he might kill them. Many of his early drawings are illustrations for the bloodiest episodes in the tragedies of Aeschylus and Sophocles, which were his preferred reading. Certain of the sculpture-objects from his Surrealist period stem directly from his attraction to scenes of horror linked with erotic obsessions, torture and madness. *Man and Woman* of 1928–29 is an almost abstract portrayal of a sexual murder or rape. The man is slender, bent like a blade for the terri-

ble pickaxe blow he is leveling at the round, concave, half-inverted form of the woman's body, which is surmounted by a broken line, like a scream or a flash of lightning. In *The Cage* of 1931, the forms tear and devour each other in a climate of convulsiveness. Another sculpture represents a *Woman with Her Throat Cut*. In *Point with Eye* of 1931, a kind of long sharp point, held in equilibrium by a nail which pierces it, menaces the eye of a tiny skull-like head fastened to a stem. The suggestion of a destructive act, halted at the fatal moment of its accomplishment, appears again in *Taut Thread*, in which a kind of flower-woman, graceful and delicate, is about to be crushed by a curved rod, like a spring which only a very thin thread holds in check.

And if Giacometti admires Callot's engravings to the point of devoting a text to them, it is because he finds striking similarities with his own obsessions in them. "There is nothing but scenes of massacre and destruction, torture and rape, fire and shipwreck," he writes. But at the same time, in Callot as in Goya, the scenes of horror and the figures of monsters or madmen are strangely linked to the same insistent evocation of emptiness, the same treatment with incisive lines which seem to rend space.

The sensation of the void which separates beings, isolates them from the world and plants an obstacle to communication is at the origins of Giacometti's instinct of cruelty. One does not violate the creature who consents but the one

Cage (First Version) 1950 Bronze 91 cm

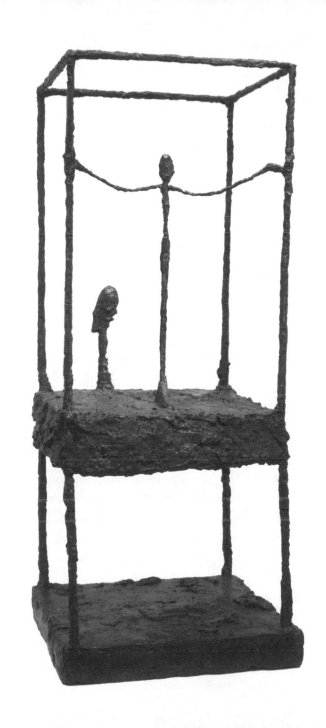

who refuses. The recourse to violence is nothing but an extreme, desperate means of provoking the impossible encounter. Giacometti's relation to reality, and his relation to his sculpture or his canvas are tinged with violence in proportion to the dissatisfaction to which they drive him. It is not compensation for defeat but an instrument designed to combat the fatality of failure, reverse the situation, penetrate the fortress. Giacometti cares little about caressing things, playing with their external appearance, the light which enfolds them, the color which diversifies them. He never shows us matter at rest, a smooth structure, a polished surface. He does not linger over appearances, but he destroys them, breaks into them by force. Hence the grinding motion when he sculpts: he kneads the earth in a rage, as though to question it incessantly and grasp its secrets through torture. In his painting he never works over all the parts of the canvas equally. The manner of a tranquil promenader in a garden is utterly foreign to him. He creates a sensitive zone on the surface (determined by the subject), focuses desperately on it and devotes all his energies to it, attacking a single point as though he wished to open a breach in a wall. He must penetrate, force his way into things, into beings and into himself, and violence should enable him to enter by surprise, overturning the barriers in a single stroke. But whatever the depth holds, it also withholds and defends the access

to it with ferocity. It does not surrender after a single assault. And each refusal provokes a new violation. One must repeat the attempt continually, endlessly keep up an act of murderous interrogation and dispute. Giacometti advances only through a havoc of canvases, a hecatomb of statues. He seems to raise destruction to the level of a method. At certain times not a single work finds favor with him. And he mistreats his life as fiercely as he does his work. In his studio a rubble of broken plaster, naked armatures, abandoned or mutilated sculptures are so many vestiges of massacres, fetes of exasperated fury.

5

In the center of the tiny, cluttered studio, lit by a skylight, Diego poses, sitting immobile and resigned on a stool: he is used to it. But Alberto, in spite of having examined his brother's face for almost fifty years, is not yet used to it. He is just as astonished as he was on the very first day before this unknown, immeasurable head, which defies and refuses him, which offers only its refusal. If he approaches his brother, the latter's head grows out of all proportion, becomes gigantic and threatening, ready to topple on him like a mountain or the angry face of a god. But if he backs away a few paces Diego recedes into infin-

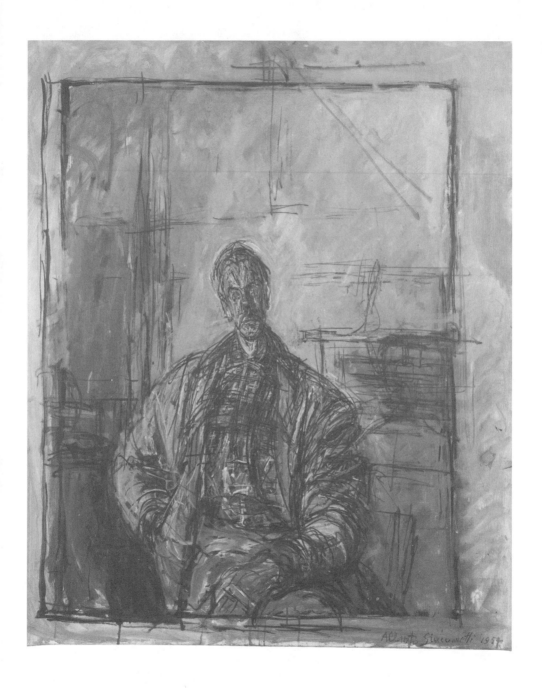

ity: his tiny, dense head seems a planet suspended in the immense void of the studio. In any case, and whatever the distance, it forbids him to approach. It looms abruptly, a separate, irreducible entity. The pure questioning of the eye, purged of all the habits which impede it, transforms Diego's familiar head into something unknown. "We know what a head is," exclaimed André Breton one day, disappointed and irritated that Giacometti preferred reality to the imaginary. We do indeed know what a head is. But the knowledge, precisely, is what Giacometti is struggling against. This false knowledge, the unverified heritage which our laziness accepts and passes on, this pretend knowledge which is the opposite of knowing and the real obstacle to the eye. The mental figuring of reality has expelled true, living perception. We do not know what a head is, and we need only look a little closer to see that we do not.

This is precisely what happened to Giacometti around 1935. At that time he was alternating between sculpture-objects with poetic overtones, which leaped fully equipped from his imagination, and flawless plastic constructions whose success, in his eyes, was confined to the merely aesthetic level. The desire to realize compositions with figures prompted him to make several studies from nature. He hired a model for two weeks: the model came to pose every day for five years. "Nothing was as I imagined it," he wrote later on.

Portrait of Diego 1954 Oil on canvas 80.5 × 64 cm

A head—I dropped the figure quite soon; it was too much—became for me a totally unknown object without dimensions. Twice a year I would begin two heads, always the same ones, without finishing them, and I put my studies aside.

Once again he had come up against this impossibility of sculpting a head which had made him give up representation in 1925, but this time he was to persist, to force himself with furious stubbornness up a path which seemed to him without a goal but also without an alternative.

This human head of incredible density is not a sum of parts or details, nor their more or less complex organization: it is the manifestation of a whole, indivisible and unanalyzable, which emerges out of the emptiness and night like a fantastic apparition. Giacometti sees it loom for the first time—at each moment for the first time—at that impassable distance which it maintains in order to be and to appear. In his attempt to represent this new head, the unknown quantity that is every head, neither his artistic culture (so many copies made in so many museums) nor his mastery of his own means of expression, nor his practiced sensibility are enough. The purified vision which reveals it demands that the sculptor discover new means and new instruments, that he re-invent them at each moment. That he abandon the hand of former days, the obsolete

tool, so as to learn everything all over again, and to approach, correct, prune, destroy and begin again without respite. Without hope. In order to fix reality as he finally sees it, in its emerging and its brutal withdrawal, all the sculptor can do, paradoxically, is to imprison it in the close knit mesh of a lived period of time, and to approach it gradually in an alarming and exhausting series of advances and retreats, with the painful knowledge that his work is only an attempt and the finished work only an approximation.

After five years of failures with the model, Giacometti attempted on the eve of the war to do heads from memory. Each time, without his intervening, they became curiously pointed. Then he reacted against this irritating deformation and fell into another trap. His sculptures, heads and figures, grew smaller and smaller. "They were only 'like' when they were small," he writes,

and yet their dimensions repelled me, and I would begin untiringly all over again, only to arrive after several months at the same place. A large figure was false for me, but a small one intolerable all the same, and then they became so tiny that they often disappeared into dust with a final stroke of the penknife.

From 1942 and the years which followed in Geneva, Giacometti saved only a small number of these tiny figurines, most of which fitted easily into a matchbox. Once back in Paris, he succeeded in realizing larger sculptures, but he

could not avoid new deformations: extreme elongation of the figures, thread-like thinness of the bodies and limbs, reduction and flattening of the head, voluminous development of the feet. What happened between the real person and his depiction, since in no case did Giacometti yield to an expressionistic intent, and since he was seeking only the pure equivalence of the work to his vision of the subject? Giacometti elongates his figures and flattens his heads, without ceasing to *copy* the model, because it is the only means of which he disposes, at a given moment of his experience, to render what he sees, to make a *likeness*. The characteristics of his work which seem to remove it from realism are merely manifestations of a superior realism, at once broader and more precise, which no longer has as objects man or the world as they are, but as Giacometti's eye sees them. "Man" of the realists, that abstraction, that mental reconstruction, has given way to the *other*, to the encountered, near and inaccessible being, who has depths within him and the void outside and around him, without which he would not be alive for us.

6

Face to face with his sculpture, we are scarcely freer than Giacometti in front of his model. For it carries its distance within it and keeps us at a respectful distance. And our relationship recreates the strictly evaluated space so that its totality, and that alone, may appear. This figure does not allow us to rest our eyes on one or another of its parts; each detail refers us back at once to the whole. It does not develop a rhythm which would gradually conduct us toward an encounter. It does not reveal itself as a series of plastic events leading to a harmony, a chord. It bursts forth in its immediate presence: it is an advent.

If we run the risk of defying the interdict, of crossing the prescribed distance, that is, if we linger over a detail, if we look at the sculpture as a sum of parts, we see it literally disintegrate before our eyes. The human portrayal gives way to that of a monstrous being, a tracked monster, inert as though pinned down between two moments of agony. A monster which has just emerged recently out of a volcano, still dripping and sticky with warm lava. This body which was that of a man or a woman is now nothing but a deformed or clenched mass, swollen and horribly distended. We are witnessing its torture and its disintegration. We slide after it into an infra-human region. We

participate in the dislocation of the human edifice through the upheaval, the insurrection of the very substance of which it is made. We are implicated in this ultimate disintegration. If this flesh is still alive, it has nonetheless been riddled, lacerated, plowed like a field and sown with plague sores. Already it is nothing but the convulsions of disorganized matter in search of a form, the petrified tumult of chaos, that chaos from which the creature came and to which it returns, and to which we would not dare to admit that man is so close.

Let us back up a few paces and once again seize the figure in its totality. The vision of chaos becomes blurred. The fury of matter subsides. The forms organize themselves, become precise, justify one another reciprocally. The mortal collisions between light and shadow are submitted to the laws of a ritual struggle, a strict dance. The volumes become ordered and equilibrated. A tolerant space develops around the figure, who comes to life again under our eyes. If the recaptured form contradicts the formless substance from which it issues and from which it is molded, it still keeps the stigmata of its terrible birth.

The figures keep us at a distance; they carry their remoteness inside them and reveal their profound being. Naked, unmasked, it is now their unknown doubles who come to light. Their hieratic attitude reveals an imperious insensitivity. They elude our understanding, reject our impulsive gestures. They do

not disdain us; they ignore us and dominate us. One would think them fastened on their pedestals for eternity, rooted to their rock. The gravity of their bearing, the asceticism of their demeanor and their gaze which traverses time and traverses us too without flinching, without suspecting our opacity and our stupefaction, gives them the appearance of divinities. They seem to await a primitive cult. Disposed in groups in a gallery or a studio, gathered in clusters in *Square*, on a single pedestal, they form an assembly of sacred figures whose distance accentuates their enigmatic likeness and their obsessive questioning. One feels them at grips with a truth which consumes them and makes them spring up out of their pedestals, a truth hardly more terrible than death, perhaps the presentiment of impossible death ... Giacometti would like to enclose his figures this way between rigorous, but intangible and moving, boundaries, beyond which they could not stray without returning to the chaos from which they issued or be condemned to the torturing lucidity of the gods, to that annulment in a sacred space which gives them the rigidity but not the peace of death.

7

Drawing is for Giacometti another breathing. In order to model or paint one must have earth, canvas, colors. Drawing is possible anywhere, at any time, and Giacometti draws anywhere, at any time. He draws to see and can see nothing without drawing, mentally at any rate: each thing seen is drawn within him. The drawing eye of Giacometti knows no rest, no fatigue. Nor does our eye, as it contemplates his drawings, have the right to rest. It is forbidden to linger over a detail, a form, an empty space. A strange, perpetual motion, without which it would lose sight of the subject, draws it on. This optical phenomenon results from the very nature of Giacometti's drawing, from its mobility which is the product of the repetition and discontinuity of the line. The form is never immobilized by an outline or held within isolated and sure strokes. It is not detached from the background or separated by a reassuring boundary from the space which surrounds it. It issues from a multitude of overlapping lines which correct and weight down each other, and abolish one another as lines as they increase. Thus the line is never continuous but broken, interrupted, open at every moment on the void but revoking it at once by its renewals, its unforeseen returns. This results in an imprecision of detail and an intentional indef-

initeness which repel the eye at each impact, as though by a miniature electric shock, sending it from one detail to the next, and from each to the totality which they produce as they disappear. These goings and comings, this dancing race of our eye, gives us the subject to see at a distance, as Giacometti sees it, in its impassible space, across the ambient void which disturbs and inflects its image.

We may note how much this highly personal manner of drawing is basically calculated on the movement of the eye in normal perception. The eye does not isolate several lines of an object to the detriment of the others; it is incapable of following an outline or dwelling too long on a detail to the exclusion of what surrounds it. All these operations are mental. The eye comes and goes rapidly, moves restlessly from one point to another and from a part to the whole. In its leaping course and its thousand capricious turnings it comes back constantly to the same object but each time in a way that is slightly different. The eye has until now scarcely found a more formidable rival in the speed of its travels than Giacometti's line.

In the majority of his drawings a multiplicity of horizontals and verticals seem to search out a certain space; they define it less than they evoke it—and invoke it—by their insistence and their indecision. This space has the peculi-

arity of being both immense and enclosed. Thus the modest dimensions of his studio always seem vaster in the drawings. Whatever the place is, it gives us a feeling of confinement, of seclusion, but in immensity. One cannot escape it; at most one is in danger of getting lost or dissolving in it. We are prisoners but the cell is as vast and mysterious as a palace or a temple. This space, which seems to illustrate the title of Irénée Philalèthe's work *Open Entry to the Closed Palace of the King*, proceeds no doubt from extremely precise proportions, from a particular density of emptiness, from a certain vibration of light which is very easily obtained and very easily compromised. For Giacometti there is no question of a formula to be discovered and applied, there is only a pursuit which he must experience intensely and render visible. And the coordinates he traces, separately imprecise, constitute together the surest approach to that privileged space, charged with a secret power.

In contrast with this scheme of straight, slanting lines, the figures and heads are obtained by dense curved lines, fluid and nervous, a mesh of lines which appear subject to a circular, or more precisely, centripetal force. If the drawn form is not marked off from what it is not by an outline or any other intangible frontier, it still has to affirm and define itself. It succeeds in this by expressing an internal cohesion, an energy folding upon itself, a kind of gravita-

tion which the network of interrupted lines reveals. In its rapid whorls the drawing carves out depth, or rather breathes it in, opens itself to it and renders it active between the strokes. It is as though a force issuing from within beings or things gushes out like a fluid through the interstices of the drawing and the porousness of the forms. And the lines must reveal this force, that is, both contain it and provoke its escape. This is the reason for their discontinuity. The interruptions and accumulations of line are never felt as superfluous repetitions and incongruous stops since they are the equivalent of the eye's mobility. On the contrary they contribute to give the objects this trembling, this feeling of truth and life. Thus it may happen that a figure may lack part of his body, and yet one sees him in his entirety. It may happen also that he is made of lines so vague, so far in appearance from the human form that he seems almost a wager or a tour de force: and yet he lives. One cannot examine him, but his living presence imposes itself with force. In extreme cases, as in certain drawings and a well-known poster, Giacometti is attracted by the vertigo of the white page, that is, of limitless space. But one must still draw, for the virgin sheet of paper is nothing—neither white, nor void, nor space. We can experience the white page, the absolute void, only when the drawing is still sufficiently sure, sufficiently present to give us intimations of its imminent suppression.

What Giacometti's drawing gives us, it gives us in a way that is both imponderable and intense. For his line is at the same time light and incisive. He grazes the paper and tears space open. He lets vacancy invade the form through innumerable fissures and simultaneously drives it off with the promptness of his repeated interventions, like a sudden swipe of claws. The purposeful indefiniteness which results isolates the objects and figures, expresses my separation from them, leaves them free, that is, in a position to choose among various possibilities. When Matisse draws a leaf with his lively and supple line, he also fixes it in a single one of its appearances and thus immobilizes it tyrannically for eternity. Giacometti cannot or does not care to gather such an image and immolate it according to his whims. As he multiplies its possibilities of seeming, he leaves the object its uncertain development, its anxious mobility. He does not draw up a single course but opens a multitude of paths among which the object can choose, or at least seem to hesitate continually, drawing from its indecision its quivering autonomy and the trembling of a separate life.

Isn't this multiplying of lines nothing more nor less than the refusal to allot significance and certainty to a single one? Here we come again upon contention as a creative principle. To trace a second line is to call the first into question without erasing it, to formulate a regret, to repent and correct, to start

a debate, a quarrel between them which a third line will come to arbitrate and revive. From dispute to dispute, all certitude is withdrawn from the form which can only appear in an interrogative mode. Doubtless we still see this landscape, this bouquet of flowers, this head, but they will not let themselves be seized. They manifest themselves only by moving away, which prompts us to call to them, to question them. Once we have discovered them we must still constantly ask them: "Are you there?" For them, being means to be questioned, invoked, to be the object of our desires. Giacometti does not hand over the world for our embrace, our consummation, but to our desire which is still kept in suspense, to our thirst for the impossible.

And for him, a successive, line by line contestation of his drawing is the only way of placing himself in the world without betraying the truth of the excisions and the solitude which his lucidity shows him. Loneliness and the urge to have done with it, the wound and the prostration followed by a new hurtling against the wall—this is also the way we ourselves enter and do not enter the space of communication that Giacometti partially opens for us and from which he is excluded.

8

Except for a few paintings done in Stampa, Giacometti abandoned the model and even all realistic figuration during a ten-year period from about 1925 to 1935, in order to interpret the human figure freely, to make abstract constructions and above all to compose sculpture-objects with symbolic or erotic content. And yet at no moment did he deliberately renounce his desire to represent reality: it was reality which abandoned him. In Bourdelle's studio or at the Grande Chaumière, he would vainly strive to copy a figure or a head from a model. If he starts with a detail he cannot succeed in a synthesis of the whole. And how can he render the whole without passing through the parts of which it is made? So he tries to take up the same subjects from memory. This results in the flat sculptures of 1926–28, which, satisfying as they are from the plastic point of view, only allude to a real head or figure. He tries again to model a bust, to paint a portrait. Reality eludes and rejects him. After a final unsuccessful attempt at self-portrait, Giacometti learned a lesson from his failures and turned from reality.

This wholly provisory decision was nonetheless the sign of a soul-searching whose consequences were to prove incalculable. Giacometti had just experi-

enced not only the divorce between classical representation and real percep-
tion, but also the absolute impossibility of a total realism. A partial image of
reality is false, a total expression humanly impossible. From this observation
one can deduce two diametrically opposed alternatives: to cast one's lot with
this impossibility, turn one's back on reality and substitute the imaginary as a
field of experience (this is what Giacometti, out of spite, was to do for ten
years); the other, which he will later adopt definitively, is an absurd and heroic
obstinacy in the pursuit of unseizable reality.

The flat sculptures of 1926–28 are the first consequences of his abandoning
of the model. These heads and figures which have the aspect of thin, smooth
plates touch us through the rightness and the sensitivity of their forms and
their proportions, but their very perfection betrays their limitations. And yet
they are not the result of a preconceived idea, but of an involuntary deforma-
tion, of an organic metamorphosis. Starting with a head or a figure as they ap-
peared to him at the time of his fruitless exercises at the Grande Chaumière,
the sculptor sees the structure become flat in his hands, the details disappear,
the surface become smooth. The thinning of the volume shows the temptation
to abolish the third dimension as much as possible; Giacometti goes as far in
this direction as the resistance of his material allows. The thickness of the

plates is thus determined by technical and tectonic reasons. A transposition without hitches but also without surprises. The flat head gives the totality of a head, simplified to the extreme by total perception, stripped to its essentials and made thin so as to give the impression of bursting forth, of a sudden presence. The extreme stylization results however in changing the head into an idea of a head, into a beautiful object. Paradoxically it is the allusions to the details of a figure, added by incising or lightly hollowing the surface, which identify the head and convey the meaning of the whole.

Although Giacometti is unable during these years to do what he really wishes, he can do everything else. The basic idleness to which he yielded gives him great technical ease and leaves the way open to imaginary creations. Out of curiosity he accepts and profits by numerous influences—the desire to see and to experience primitive and archaic art and that of the moderns, especially the Cubists, Laurens and Lipchitz. He participates in the experiments of his contemporaries and generally surpasses them or anticipates their discoveries. Affective stimulations converge with problems of construction and the quest for space, leading to extremely varied realizations. To the primitive fascination of the 1926 *Woman* (known as *The Spoon-Woman*), in which the erotic mechanism of attraction-repulsion is suggested by the opposition of the body, an immense cavity, welcoming and auspicious, to the hard and angular masses of the

head and the bust. Or, again, to the *Couple* of 1926, which juxtaposes the trape-
zoidal volume of the man and the fish-shaped ellipse of the woman in a rough
and barbaric contrast. Most of the sculptures are thus transpositions and vari-
ations on the human figure, accomplished through vigorous oppositions of
round or circular forms and angular masses, analyses and syntheses of struc-
tures in space in which it is difficult to locate the realistic point of departure.
These assemblages of alternating forms, this rhythmic accentuation of the
void lead Giacometti to the idea of the open sculptures of 1928–29 which he
purposely calls "clear structures." These are ideas rendered concrete in three
dimensions, "forms in space; open, airy constructions, so as to slough off the
mud." He banishes closed masses which confront space. Vacancy traverses
these sculptures and animates them, and it is by this means that the symbol
catches fire, that oppositions and accords spring to life. *The Reclining Woman
Dreaming* dreams in horizontal planes which undulate like waves and whose
calm cradling motion is emphasized by the supple pilings which support her.
In its simple and geometrical construction, *Apollo* rises like a harmonious di-
agram, a grill traversed by space as a messenger of light.

Vacancy participates in the sculpture; it is visible, alive, sometimes disturb-
ing. It takes over forms, separates and brings them together again, hollows
them with its whirlpools or slips dizzily down smooth, profiled structures. It

sometimes takes on an oppressive character of dreams and cruelty. *Man and Woman*, unlike the *Couple* of 1926 which juxtaposed two figures with contrasting forms, unites them this time in a rigorous image of murderous love. Almost forming a cage, the *Three Figures Outside* of 1928–29 reduces the men to straight verticals and the woman, who seems to evoke a lascivious dance between the two rivals, to a quadruple broken line.

With the *Cage* of 1931, eroticism takes on a convulsive and agonizing character, as much through the aggressive modeling of the bars which enclose space as by the exasperation of the forms and their furious modeling. Giacometti was haunted by the inside of things, especially of the human figure. This *Cage* is like the inside of a thorax, and what is being torn and devoured there represents the functioning of the human organism in its implacable autonomy. If man cannot be seized on the outside, by interrogating his visible aspect, the temptation is strong to recreate him with the imagination when the imagination is stimulated and oriented by subjectivity's obsessions and passions. The clear transparent structures are to represent organic visibility: they are mentally precise constructions capable of being executed from their imaginary representations.

This same cage becomes, in *Suspended Ball*, a simple and clear geometrical

construction and the same obsession expresses itself in an encounter of extreme and suggestive simplicity: a cloven ball, suspended by a thread, which can slide along a crescent shape. A perfect symbolic object, which fascinates by its elementary obviousness, but in which the possibility of an effective motion, an obsessive motion which is a swinging motion, disturbs its deceptive calm.

Several sculpture-objects between 1930 and 1932 also avail themselves of real or suggested motion. In *Point with Eye*, a movement which is suspended, halted in its paroxysm, gives the feeling of the lightning-like speed of a point piercing an eye. It is an atrocious mechanism which suggests both a child's toy and a model conceived by a sadistic engineer. Other objects pose enigmas. In *Circuit*, a marble rolls endlessly in a circular track, while its place, its repose, are prepared elsewhere in a tiny cavity inaccessible to it. Motion as the expression of the vanity of all motion reappears in *Man, Woman, Child*, where the elementary forms which represent the figures move without being able to join each other. *Hand Seized by the Finger* is a horrible system of gears which draws the finger and the whole hand into the perpetual motion of its wheels and pulleys. Giacometti, who could no longer bear the illusion of movement in sculpture, reacted by introducing a real motion which could be identified in

most cases with the perpetual motion of solitude, with the erotic and cruel mechanism of his profound dreams. He speaks in one text of "pretty, precise mechanisms which have no use." His own, however, serve as vehicles for the mental imaginings he thus rids himself of. Dissatisfaction, revolt, bitter humor lead him to realize works of provocation and anti-sculpture: these are the *Disagreeable Objects, To Be Thrown Away* of 1932. These objects without bases, which one can place in various positions, all equally valid and equally absurd, are pure manifestations of undisguised aggressivity.

More and more the contradiction between work (useless, gratuitous) and life tormented Giacometti, who, from 1932 on, is above all concerned with expressing what he lives and feels, his conflicts, passions, desires and dreams. Like a chessboard whose squares have been replaced with circular cavities of different diameters, *The Game Is Over* presents a man and woman who gesture to each other from far away; between them is an empty zone comprising three rectangular holes, like tombs with their lids; one is empty, another shut, the third contains a skeleton. We find the same obsession in *The Palace at 4 A.M.*, a kind of complicated cage in which are found a backbone, a bird's skeleton, a phallic form and a female figure in a long skirt; but they are separated and some are shut up in a second, smaller cage. The orientation, placing and

respective heights of these objects seem very precise, as though they were the plotted equation of a nightmare. Here again we find the obsession with the cage and the skeleton, with the clear structure and the hard structure identified as man's truth and the sign of his death. The cruelty and the fascination of terror are even more precisely the inspiration of *Woman with Her Throat Cut* and *Taut Thread*, which represent the temptation of communication through death and destruction. *The Table*, the materialization of a pure hallucination, supports the bust of a partly veiled woman between a severed hand and an enigmatic polyhedron. Giacometti approaches reality without leaving the climate of dreams in three versions of a long, thin and very disturbing *Walking Woman*, whose proportions, but these alone, announce the future elongated figures. The sculptor was hovering at the time between abstract form, plastically and aesthetically satisfying, and the concrete realization of his dreams and obsessions; between the mysterious seated woman of *The Invisible Object*, predominantly affective, which he wanted to destroy because he found her too sentimental, and the polyhedric sculpture of 1934–35 which, in its limited perfection, is no longer anything but an aesthetic object without content. He strives to reach a synthesis in the *Head-Skull* of the same period. Actually the subject lends itself admirably to this treatment. It is first of all a

powerfully suggestive reality to which Giacometti is extremely sensitive. Also, through its very structure, it calls for and facilitates a rigorous plastic interpretation. Concentrating closely on construction and expressing simply one of his deepest fantasies, the sculptor manages to reconcile geometrical construction and hallucinatory magic.

But this contradiction, resolved for a day, returns to torture him. Imaginary and inner reality attract him, but clash with the formal demands of the constructor and the plastic artist. In *1 + 1 = 3*, harshly derisive of woman, he does not escape the dilemma and is almost at the end of his non-representational adventure.

In all the work of this period one hesitates to say who is triumphant: the fantastic poet or the abstract constructor. Giacometti finds relative satisfaction in the creation of plastically rigorous sculptures, in the search for abstract harmonies and flawless structures. He likes also to be invaded by the flux of images and unconscious imaginings in which, when he succeeds in grasping them, he discovers the profound mechanisms of emotional life and the constants of his being. But what stays with him more than anything else, no doubt, is despair of reality, and his nostalgia shows through the narration of dreams and the plastic experiments. When he evokes the human face, and this is al-

most always the case, it is to tell passionately again and again his powerlessness to attain it. A defeatist attitude, with which he tries to persuade himself to renounce reality without really breaking with it, all the while preparing unconsciously, deep within him, his return to the visible world.

9

In 1921 during a trip to the Tyrol made in strange circumstances, Giacometti spent a day alone in a hotel room with his traveling companion who was dying.

> *I watched the head of Van M. being transformed; the nose became more and more accentuated, the cheeks grew hollow, the open, almost immobile mouth was hardly breathing and, towards evening, trying to draw his profile, I was seized with a sudden panic before his oncoming death.*

"This event," Giacometti continues, "was for me a kind of breach in my life. Everything became something else, and this trip obsessed me continually for a whole year." And will obsess him, perhaps, for a whole lifetime, considering that this revelation has not yet exhausted all its consequences. It announced

what the sculptor would discover much later, scrutinizing with a scalpel-sharp gaze the appearance of a human face. Before the insistence of such a look, the model is metamorphosed, gives way to the human being in its terrible stony nakedness. The eyes become black excavations. The perfection of the skull, the frightful tongs of the jawbones and the grooves of the teeth show through the skin. Doubtless the primordial need for a sculptor to discover structures makes him come forth to touch with his hand the mineral hardness of the skeleton and the skull. But this explanation is insufficient. One must also take into account the feverish passion with which Giacometti perseveres in his pursuit of truth, of a likeness, and tracks it down to its final lair. He will remain haunted by the idea of death and overwhelmed by the signs of its manifestation. He will seek to rid himself of the obsessive image of Van M., dying, his mouth open, when he models the hallucinatory *Head on a Stem* of 1947, whose impalement seems to wrest a silent scream from it. It is terrible in a much different way than the *Skull* painted in 1923, which Giacometti finds "in one sense as perfect and as living as anything alive." Again, evoking the sight of a corpse: "I looked at this head become an object, a little box, measurable, insignificant." The head is measurable and an object only when it is dead. We must return to that which lives, to the presence of death in it, to the active presence which

sustains it and is its framework, which rears it above things but at the same time rejects it beyond recall from the world and from others and walls it up in its solitude. Thus, in different moments and works, the human face seems stricken with stupor, halted in its drive, wrenched by surprise from the convulsions of death-agony, or more often torn from tranquil contemplation, beyond the emptiness which assails it from every side.

This revelation penetrates the sculptor's vision so strongly, around 1946, that he experiences its effects constantly in the most ordinary circumstances of his life. "At that time," he writes,

> *I began to see heads in the emptiness, in the space which surrounds them. When for the first time I perceived clearly the head I was watching grow rigid and motionless in an instant, forever, I trembled with terror as never before in my life and a cold sweat ran down my back. It was no longer a living head but an object which I looked at like any other object, but no, in another way, unlike any other object, but like something simultaneously alive and dead. I cried out in terror as if I had just crossed the threshold, as if I were entering a world never seen before. All the living were dead, and this vision was repeated often, in the Métro, in the street, in a restaurant, with my friends ... That waiter at*

Lipp's who became motionless, leaning over me, mouth open, with no relation to the preceding moment or the next, his mouth open, his eyes fixed in an absolute immobility. But at the same time that men underwent a transformation, so did objects—tables, chairs, suits, the street, even trees and landscapes.

This morning as I woke up I saw my napkin for the first time, that weightless napkin, in an immobility never seen before and as though suspended in a terrifying silence. It no longer had any relation to the bottomless chair or the table, whose legs no longer rested on the floor, barely touched it; there was no longer any relation between these objects separated by immeasurable chasms of emptiness.

The phenomena which affected his seeing brought a complete change to the outer appearance of beings and things. Giacometti discovered only silence and immobility around him. Even in a noisy and bustling scene, the world seemed totally silent, totally immobile. He had an acute sensation of inertia, of silence, of the death of things. Time seemed abolished, reduced to a succession of discontinuous moments, stopped (as sculptures and paintings actually are, silent and immobile in relation to the movement which they express, or to the creative lapse of time from which they issue). This perception of arrested, suspended life was for Giacometti an experience as overwhelming as that of

the mystics, but that modestly affected only the appearance of everyday real-
ity. As though death had come down all around him. Or rather as though he
had been transported to a place beyond death where the spectacle of life was
like a hideous simulacrum. A frightening sensation, as the quoted passage
shows, but at other times an exalting dizzying discovery of a reality completely
transformed, saved from all erosion, restored to its virginity. One day in 1946,
leaving a movie the falsity of whose images had tormented him, Giacometti
thought his eyes had opened for the first time. The Boulevard Montparnasse
with its café terraces, its trees, its passersby, plunged him in a daze and a won-
der of which he had hardly until then anticipated the possibility. Reality ap-
peared to him suddenly of a richness and beauty superior to all dreams, artis-
tic creations or the imaginary world of poets. He trembled with emotion
before a table or a glass, before reality which is "terribly superior to any surre-
ality," as Antonin Artaud remarked. At the same time his work with models,
particularly Colonel Rol-Tanguy, provokes in the sculptor analogous sensa-
tions, but in fortunate circumstances which allow him to explore them more
deeply. Returning to the human head, he does not stop at the hard structure he
had laid bare and which displayed the motionless presence of death. Rum-
maging deeper in the face, penetrating the wall of bone which death had ap-
plied to it like a mask, he sees and gives to be seen the living depths which in-

habit it. For life is within, walled up in the skull and the bones, filtering through the slits of the eyes, circulating in the vertebrae like that pillar of fire which, according to the science of the pharaohs, sustains and irrigates the human edifice. Life gushes forth from death and takes refuge in it. Though an invisible presence, it attracts and retains the eye by acting on the outer appearances of which it is a prisoner, in changing what I see. The vision, simultaneously purified and enlarged by the revelation of the internal dimensions of beings and things, suffices to change the aspect of the world. The latter, finally seen (and not imagined, interpreted, re-invented) is a prodigious, fantastic spectacle, infinitely rich, since everything in it simultaneously reveals and hides its unknown face. The overwhelming effect which depth has on real appearances at these moments must then be seized and expressed by the painter and sculptor.

10

To build a wall, the mason adjusts his stones one after the other in a logical order, in this case beginning with the bottom and finishing with the top. Similarly the artist's labors are subordinated to finishing the work, each of his

movements is directed toward that realization and has its own function as does each of the mason's stones, within the limits of his project. But because his vision of the world and the meaning of his undertaking command it of him, Giacometti must on the contrary immediately seize and express the whole of the object he is depicting. No one can force a head more quickly out of clay or onto canvas. But having made it appear, he must continue indefinitely to seek it, to approach it, since what he has set out to represent is the distance and the refusal of that head, the impossibility of absolute communication which it means to him. From the first moment the diabolical mechanism is in operation. Giacometti's eye and hand never stop. He smokes, chats, thinks of something else, but at the same time in a kind of hypnosis or second state, the eye and the hand continue to come and go, to do and undo, while on the sidelines the painted face or clay figures rise up with haughty intensity, as though detached from the wild effort, the incessant torture which are creating them. When will Giacometti stop? He cannot stop. When he lets a sculpture leave the studio, it is because of an arbitrary, insignificant decision. He does not stop, he interrupts the work in progress. Throughout all the sculptures, paintings and drawings, he pursues one and the same attempt to approach reality. The work is single, unfinished, impossible.

His not stopping means that he never stops looking at and depicting what he sees, in any circumstances and at each minute of his life, even if he is not "working." In the café he draws on his newspaper, and if he has no newspaper, his finger still runs over the marble top of the table. If his hand is occupied his eye still draws. He draws as he walks in the street, and when he sleeps. His not stopping means too that Giacometti can only present us the rough draft of an unaccomplished, unfinished undertaking. A reflection, an approximation of reality—of that absolute reality which haunts him—and which he pursues in a kind of amorous or homicidal fury. He pursues it and approaches it. That the end is inaccessible does not as a matter of fact exclude the possibility of progress. And Giacometti places himself in a perspective of progress which seems to him even to obey a law of continuous acceleration. According to this Mallarméan arithmetic, a future minute could represent a year of past work. In a month he could go through as many stages as he once did in ten years; and in front of him seems to stretch the perspective of several lifetimes of work. The fantastic acceleration of the time necessary for creation would thus be the equivalent of a slowing down, a progressive spinning out of the actual duration. His optimism is thus as disproportionate with regard to the relative as his pessimism is categorical with regard to the absolute. Yet people readily accuse

him of repeating himself, of marking time, especially when he neglects works (such as *The Chariot, Figurine in a Box, The Nose*) whose affective, experimental, sometimes anecdotal nature resulted in a seeming diversity. In returning untiringly to the bust of Diego, the standing woman, the walking man, the portrait of the same model, he may discourage the inattentive spectator, but his austere research allows him to concentrate his ways of approaching. The slower his walk toward his goal appears, the more rapid it actually is. Each acquisition is definitive, each progress irreversible. But progress plays only with imponderable elements. A single line can stop it a whole night and hold up the whole work with the question of the exactness of its inflection. Giacometti's not stopping means also that he does not stop advancing.

11

We walk in the street with our eyes closed. We see only through the deforming prism of contracted habits, of a blinding knowledge: we see those passersby only as we *know* they are. If I call this knowledge in doubt, if I purify my eye of all the mental correctives which dull and estrange it, everything changes. These same passersby issue from a wide lateral opening; the immense space

which imprisons them makes them appear small, thin, nibbled by the void, almost undifferentiated and especially elongated, drawn out by the accentuation of their verticality. The eye does not distinguish, *at first*, the butcher boy from the office worker. Its spatial perception retains almost nothing of their peculiar natures, except the indications of their movements: this one walks, that one leans toward the ground, that other one holds out his arm. It is thus that the eye really sees and it is thus that Giacometti represents beings and things: in their distance, in their space, hence by depicting that space, by incorporating into his figures the distance which separates them from him. He represents what he sees and sees what one doesn't dare see, because he has been able to effect a true liberation which is not that of reality but that of the vision. He has thus brought himself to the antipodes of the teaching of the Academy, anatomy, and the classical tradition which disregard the distance of the subject and demand that one respect reality as it is and not as it appears. That reality, objective and measurable, is an object of science, not the subject of a work of art.

The purified perception of Giacometti is equally opposed to the instantaneous and mechanical objectivity of photography. The lens does not transmit distance and does not know how to sort out and grade the messages it receives. It collects, and transmits to us a mass of information which the eye would in

reality gather by repeated forays. It transcribes everything but the essential, our relation to the subject, that is it sees nothing or it kills what it sees. Also the lens is at best an eye cut off from life, with no connection to the density of existence, to the experience and depth of a human being. The eye on the other hand plunges its root, its optic nerve, into a rich and active interior which intervenes strongly in the phenomenon of perception, projecting inner space into real space to modify its coloring. The visual distance is added and combined with an affective distance which, in Giacometti's case, will move the person or thing looked at ever farther away. Finally the photographic lens operates instantaneously; the artist, in his relation to his model, establishes duration. The new, penetrating look which sees the model for the first time at every moment, with the freshness, intensity and violence of the first meeting, must paradoxically be attained through the exercise of prolonged contemplation, through insistent questioning. The essential is not granted at first glance. This virginity of the sight, its power to lay bare and deepen a relationship, might even be the inaccessible goal of continual interrogation; one can but dream of it and work at approaching it. Thus the model is not represented the way she is, nor the way anyone might see her, but the way that a unique individual, with his particular memory and affectivity, patiently questions her

and questions himself through her. In one sense the artist always creates a self-portrait.

The characteristics of this vision are more clearly highlighted at certain stages in the sculptor's experience. Thus, from 1940 to 1945, Giacometti, without seeking anything but life, the likeness of a head or a figure, experienced with each try the same phenomenon: the figure's size diminished progressively until it became tiny and often completely disappeared. The figurines which survive are astonishingly true in their distance and in the expression of their separate lives. Reduction obliges one to take a total view of oneself, hence to become strongly aware of all the space around them. They are small in size but big in proportion. For the first time Giacometti dissociates dimension and proportion in expressing size, and this discovery will have the most fertile consequences. As they become tiny, the figures call attention to the enormity of their pedestals, and this disproportion defines their distance. Soon Giacometti will translate the "remoteness" of the personage by playing with the relation of the figure to the pedestal: the larger the pedestal in relation to the sculpture, the farther away the figure appears to be. The precision of this quantitative measure contrasts with the inevitable but highly significant imprecision in the treatment of details. Obviously there can be no question of modeling the

ear or the hand of a man no taller than a fingernail. But one sees that this forced imprecision contributes to the rightness and the truth of the ensemble. The impossibility of stopping at the part sends one back to the whole, communicates the sensation of the totality of the figure in space. This discovery too is decisive. It will allow Giacometti, around 1946, to return to sculptures of normal dimensions. The characteristics of the tiny figurines, inherent in their size, will survive in dimensions which no longer oblige them, this time expressing the distant totality of the personage. In addition, we find again in the sculptures of this period the imprece construction, the disproportion of the volume of the pedestal. The determining of space will also be effectuated simply by boundaries in the form of rods which outline the edges of a cube, as in the *Cages*, or else by placing the figure between two rectangular opaque boxes, as in *Figurine in a Box*. Whatever their dimensions, the figures are large in their proportions; their thinning and lengthening communicate violently the feeling of an immediate presence. The lengthening is in a way the plastic translation of the words "he arises" or "he stands up" which correspond both to the pure perception of a man in space and to the feeling of incommunicability and separation which Giacometti experiences.

The rendering of movement in the sculptures, starting in 1947, is another

consequence of distant, spatial perception. The movement, the attitude, the gesture disturb space, cut it up, sculpt it, and the eye records its slightest changes. Giacometti did several versions of the *Walking Man*, the *Capsizing Man*, *The Hand*, *The Man with a Finger*, because he was struck by signs of movement in his vision of space. But inversely he treats such subjects in order to communicate his distant vision and to render visible the space around a figure. To sculpt a walking man is also, in a sense, to depict space agitated and modified by the walker's passing.

Finally, the movement of one figure leads almost inevitably to depicting the movements, conjugated or not, of several figures. An immobile figure surrounds itself with closed space. A figure in motion opens space and attracts other figures there, without however meeting them; in open space, solitude is plural.

From 1948 to 1949 date the *Group of Figures* and the *Square*; the pedestal widens, becomes the very precisely circumscribed place which permits walking men to pass each other by in mutual ignorance, to avoid without seeing one another. Impenetrable solitudes in motion, but subtly attuned by the unity of place and space which they reveal. A hidden organizer still directs the respective placing and orientation of the figures. The *Square* and *Forest* of 1950 are

on the contrary free of this constraint. Looking at the floor of his studio arbitrarily strewn with figurines placed close to one another, Giacometti found that they "worked" just as they were, that they formed a whole as satisfying as the composed groups. And he had them cast. But one should not imagine that this result was a triumph of objective chance. If several isolated figures are right in actual space, the group they form by being brought together—whatever their differences of position, orientation and scale—will be necessarily right as well. Outside in the street, any group of passersby is as "true" as a single individual, because it is situated in actual space. A director is necessary only in conventional space — in the theater or in painting.

1 2

When I mention the anguish of communication in connection with Giacometti, I mean the impossibility of absolute communication and not the difficulty of being and living with others. For, since childhood, Giacometti always loved to charm, dominate and fascinate, and his gifts, his intelligence, his charm and physical ascendancy, his cleverness and obstinacy, the force of his singular personality, apparent to everyone, did in fact enable him to charm,

dominate and fascinate in all circumstances. At school in Schiers he was gifted in all branches of learning and passionately fond of literature, science, politics and, of course, the arts. His precocious intelligence, his amazing memory and his faculty of assimilation enabled him to take up any new studies and investigate them thoroughly without sacrificing the time necessary for conversation, games and friendship.

He so pleased his teachers that he was given permission to set up his first studio in an empty loft at the school. His friendships with classmates were as easy as his relationships with his parents and brothers had been; they have remained close, affectionate, understanding and free. Since then, whether at the Grande Chaumière, among the painters of Montparnasse or at the center of the Surrealist group, he never had any real difficulty in his relations with others. On the contrary he attracts and charms the people he meets or seeks out, for he seeks contact with others with a passion and an avidity which one day caused him to remark: "I would give all my works for a conversation."

And yet ... And yet an obscure and profound dissatisfaction subsists which he is all the more compelled to project into the absolute since he can scarcely nourish it with failures in ordinary human relations. Fully gratified, Giacometti remains essentially destitute. Surrounded, admired, he only experiences

his solitude the more, and with it, the temptation of a total communication through murder or love but even more by an annihilation in love, or through the work of art, but in that case in the infinite pursuit of an impossible work of art. What he retains from childhood, what he writes of in any case, is not the games or rambles in the countryside but the memory of certain objects or certain places, "trees and stones more than anything," in which he recognized a friendly, protecting presence. A shelter dug in the snow, for instance, or

> *a golden-colored monolith with the mouth of a cave at its base: water had completely hollowed it out inside. The entrance was long and low, barely as tall as we were at that time. Inside, certain places were deeper than others, and at the very back it seemed as if there were another tiny cave. It was my father who showed us this monolith one day. What a tremendous discovery. I at once felt this rock as a friend; it called to us, smiled at us, like someone you used to know and love and whom you discover again with infinite surprise and joy.*

He adds: "All the rest was vague and insubstantial, air which catches hold of nothing."

All the rest, that is the outside, the distance from the others, that immeasurable and foreign space for which Giacometti tried to substitute an enclosed,

auspicious place, the monolith, the studio, and above all the often-pursued space of the work itself. At this price, proportion becomes real, entrenchment fertile, and the approach to another, to the unknown, a fantastic adventure to be undertaken. But the privileged space is obtained only for an instant, to vanish and spark the pursuit once again. The interior is as threatening and as fleeting as the exterior. The studio is only a fragile transparent prison suspended in the void and enclosing it. At each moment one must lay its foundations, rebuild it again. Four walls, or any other boundary, against the dispersal, loss or change of something essential whose growth and chances must be safeguarded against external aggression and internal disintegration. But above all to prepare oneself to face under less precarious circumstances that aggression and disintegration which inevitably occur. Thus Giacometti leaves the studio and himself only the better to return to them; he does not leave. He is the opposite of an escaped prisoner; he is a recluse. Is he immobile, halted? Quite the contrary, but he has chosen once and for all to do without the illusory aid of open space and so to travel more freely, that is with extreme difficulty, in the only dimension in which he hopes to advance: depth.

Giacometti shuts himself up, concentrates. He remains faithful to his friends, his passions, his obsessions. He has occupied the same studio for thirty-

five years, haunts the same neighborhood, the same cafés and has changed nothing in his way of life, as singular as it is regular and almost ritualistic. In the same way he doesn't attempt to vary his subjects, the attitude of his models, the lighting in his work, the colors of his palette. He is capable of shutting himself up for a hundred nights on end with the same model, of tracking the same face a hundred nights on end. He detests change and disdains travel.

The only journey which Giacometti regularly allows himself is not a journey but a return. Just as, in the studio, he will step back so as to tear himself away from a sculpture, to recapture it and regain control at a distance, so he returns periodically to be with his mother in Stampa, in the mountain valley where his roots are. A high, narrow valley, where the mountains are Swiss but the dialect Italian. This is all I know of the place. Of his mother I know only a few portraits and the almost sacred feeling of admiration and piety her son has for her. Yet it is impossible to come near Giacometti without turning toward her. She personifies the presence and the permanence of that deep-rooted fire which sustains the sculptor's work and his existence, that source and that foundation to which he is attached by an essential bond. A nutritive bond which allowed him to leave home without expatriating himself, to expose himself to the dangers of an extreme adventure without breaking with his beginnings.

She is the pole, the fixed center that assures the orientation and the tension of this spiritual experience. A watchful and silent guardian, she seems by her presence alone to nourish a tradition, not a repertory of obsolete forms but an inexhaustible lode of energy. Through her mediation, Giacometti's link with the earth, with the substratum, with depth, is as powerful as it is invisible. One feels behind each of the sculptor's gestures, each of his words, the impulsive force and the subterranean echo of a back country which he does not need to reveal, that is, to verify, so secretly active is it within him. His mother seems by her demeanor alone a proof of this. In addition, her great age, to whose trials she seems immune, gives her an almost mythological dimension. One is tempted to evoke some inaccessible and benevolent mother-goddess, firmly entrenched in her mountain, and, like the monolith, destined to conjure away dangers. Outside of her, of what she personifies, illuminates and permits, "all the rest is vague and insubstantial, air which catches hold of nothing."

13

It is arbitrary to separate Giacometti's painting from his sculpture. His first picture, *Apples*, dates from 1913; his first sculpture, a head of Diego, from 1914.

Since then the sculptor has always painted, the painter has always sculpted. The two means of expression are nothing for him but the tools of the same research and the same experiment. They complete each other, support each other mutually; the exchanges between them are constant and each advance in one has immediate repercussions on the other. It may happen that color brings a confirmation or an indication to the expression of a modeled figure, and Giacometti has in fact often dreamed of painting all his sculptures. Inversely, the subject of a picture is often a figure on its pedestal or sculptures in the studio. In these cases the remoteness of the figure is increased by this figuration twice removed, which locates it on the inside of a double transparent enclosure. For the problems of distance with which we have seen the sculptor struggling pose themselves in identical terms and with the same intensity to the painter. Only the circumstances differ: deprived of the faculty of playing with real space, Giacometti has to find in the two dimensions of his canvas other means of creating distance than those he uses in sculpture.

Hence he almost always surrounds his compositions with a false frame of neutral color or rough drawing. This tangible limit traced by hand attenuates first of all the geometric rigidity of the stretcher. Above all it allows us to see the subject through an indefinite and ambiguous opening which at once cre-

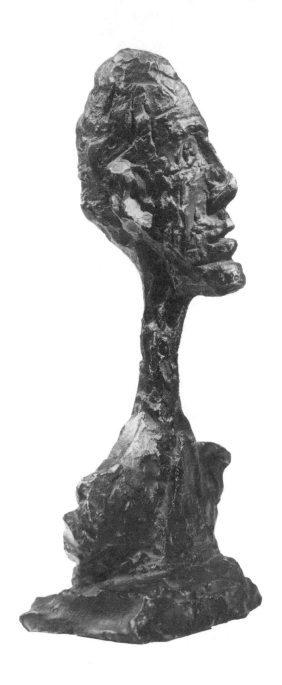

ates the illusion of remoteness. This false window plays the role of the "cages" in the sculpture, tightening space and increasing its density as one might com press a gas. The painter will still determine the measurement of the distance with precision by effecting the dimensions, the proportions and the construction of the false window. But he does not resolve this problem in the abstract, through some mental operation; on the contrary he seeks his "distance" on the scene of the action, the canvas, by successive estimates and gropings whose traces remain visible. So that the manifestation of this blind search for a distance at once tactile and metaphysical, also has the character of an anxious appeal, a wait, an entreaty as though the favor of the gods would confirm the surveyor's ungrateful task.

Thanks to this calculated remoteness, the relations which we may have with the subject of the painting exclude all familiarity and forestall any ill timed intervention on our part. This figure, for example, does not suspect that he is being looked at; he is alone in his space, foreign to the things which surround him, lonely and exiled in the midst of the studio which has become immense, imprecise, disturbing. Formerly (around 1946–47) the decor was sometimes rendered with all its details but by a multiplicity of lines which referred one back to its basic indefiniteness. Today, it is hardly sketched in, or else

Diego's Head 1955 Bronze

treated with utter unconcern. The lack of differentiation of the backgrounds sets off the isolation of the subject and reveals the presence of emptiness around being and things. The figure occupies, without inhabiting it, a vague, mysterious, dilapidated space; apples graze the table which remains in ignorance of the other furniture, and whose legs scarcely rest on the floor. The background is purposely left to itself; gray and formless, both dirty and luminous, it takes on by turns the aspect of an ocher mist, a cloud of soot, of leaden or silver pools or vapor. Traversed by vague currents whose light and shadow sluggishly oppose or penetrate each other, it gives the sensation of a substantial but neutral and unreal space, whose colors are those of waiting and foreboding. It is a propitious space for apparitions. Seemingly random lines cross it, organize it, detach in passing the outline of an easel or a sofa. Careless indications, but they give this immense uncertain space its exact dimensions, and provide unreal space with its own sensory quality.

The uniformity of the subjects is more striking here than in the sculpture, for the latter means of expression traditionally implies a restriction if not a codification of the subjects. One sculpts a nude, not a woman in her bath. In painting, diversity is the rule; the limitation to two dimensions paradoxically allows one to represent everything. Yet Giacometti hardly varies the subjects

of his paintings. The landscape is almost exclusively the houses of the rue d'Alésia or the trees against the background of the mountains of Stampa. The still life is apples, bottles, a bouquet, a few familiar objects on the table. Or else a corner of the studio, the stove and the coal scuttle. The faces are those of the same people from his close-knit circle: his wife, his brother, his mother, his usual model, Caroline, Lotar. The seated person, his hands on his knees, does not change his pose. The nude is standing, her arms hanging close to her body. And all the heads have the same expression, the same bearing, the same fixity. This uniformity of subject in an artist for whom "in every work of art the subject is primordial, whether the artist is conscious of it or not," is most revealing. The explanation, as we have seen, is that the subject of the picture is not Diego or Annette, is not yet Diego or Annette, but for the moment Diego withholding himself, Annette unattainable. If he were to change his model oftener, Giacometti would perhaps experience less vividly the necessity to change himself, that is to advance, to explore each new work a little further. But there is a simpler reason: the more known the model is, the more unknown he is. The insistent, obsessive questioning of a human being (or any other subject) finally strips him of his known part and uncovers the unknown which is all in depth within him. The model lends himself all the more submissively to this laying

bare when the painter ceases to linger over superficial details and particularities which might distract him in a person chosen at random. An occasional model might give a portrait that would be more like, would resemble the model more and Giacometti less. The longer the sittings last and the oftener they are repeated, the more the model will resemble Giacometti, to the detriment not of the profound personality of the model but of its surface particularities. One evening at a café, Giacometti looked at Annette with insistence.

She was surprised. "Why are you looking at me like that?" "Because I didn't see you today." Annette had just posed the whole afternoon for him. He had not seen Annette, but the unknown stranger, the model. The creature close to us becomes a stranger, the unknown par excellence, revealing man and the world as unknown, revealing him, Giacometti, to himself as an unknown being.

Giacometti's paintings are painted less with colors than with lines, and his palette is as restricted as his subjects. A range of grays and ochers; black, white and gray lines are apparently sufficient. But within this dominant tone, where all the nuances and transparencies of gray echo each other, appear colors, rare

and scarcely exuberant ones, discreet and refined, drawing a sure power from their very restraint, from the rightness of their pitch or their place. The abuse and exasperation of pure or mixed colors to which painters have habituated us have ended by blunting our sensibility and smothering color in its own excesses, leaving us with an insipid impression of grisaille. Starting with gray and using it as an alembic, Giacometti re-sensitizes colors, gives them back their subtlety and their acuteness. They emerge from gray but remain suspended in it. They no longer act on their own, but are strictly subjected to the necessities of a pictorial language, itself dominated by the subject. That is, they obey that gradation in expressive intensity which mounts from distances and inanimate things to the human face, passing through familiar objects and places. As one draws near the face the intensity increases and the difficulties of portrayal increase. The light fails, the color becomes dimmer. Thus the still lifes are generally more colored than the portraits and less so than the landscapes. In the latter, despite the alliance with gray, the color sings, the greens of the foliage respond to the blue of the sky and the red of the bricks. The grays of the still lifes are already denser and more encroaching, and in the figure paintings they are the very color of that unfathomable and hallucinated space

of which the figure is captive. They create obsessions, dull the light and sometimes make it well up behind the head which then seems surrounded by a mysterious halo.

Giacometti's paintings are painted less with colors than with lines, because color is the quality of surfaces and parts, and, as we have seen, Giacometti precisely refuses to give expressiveness to surfaces and parts. The eyes are blue and the lips red, but Giacometti does not paint eyes or lips, but the distant totality of the face and the depths which it reveals. The vacuum which exudes the vague and dense skein of lines of a face cannot be anything but gray, the canceling out of the colors of the spectrum, the color of refusal and the impossible.

The circular arrangement of the picture around a central point also indicates the character of the line, which, as I have already indicated, plays the chief role in it. We again come upon Giacometti's so characteristic line—rapid, discontinuous, indefinitely repeated. Preferably black, white or gray (but it may happen that a thread of color intrudes in its meshes), it defines forms less than it calls on them to reveal themselves by multiplying within the outlines. Its frequency and its insistence increase as it nears the center. Thus, in a portrait, Giacometti treats the background hastily, lingers but little over

the body and the arms, to apply all his care and effort to the head. Although often barely sketched in, it is the décor which is located and fixed. The head is all the more vague and fleeting for being worked over, weighted with color and loaded down with line. For the looming of its totality, that is, the condition of its truth and its likeness, depends on the indefiniteness of its parts and the eruption of its surface. The face appears like the arena of a fierce combat; it is there that the match is played, that the frenzied interrogation of the eye takes place, that the most precise of all instruments, the eye and brush together, must operate with patience as well as cruelty. The immediate presence demands rapidity, violence of attack and penetration, but the definition of distance implies minute care in the approach. Without moderating its fury, this contradictory instrument pursues sometimes for nights on end a single undiscoverable line. The struggle has its ups and downs, its successes and reversals. From one day to the next the portrait can vanish, reappear, disappear again, revive again; and nothing allows one to foresee the outcome. A constant pursuit in the form of successive contentions. A line is added to another line, obliterates it and advances. Innumerable lines which outline nothing, define nothing but which cause something to appear. More than in the drawings, the line explodes, crumbles, scatters into segments which mingle with the brush-strokes.

Multiplying and dividing, the lines seem to cancel each other out and vanish in the totality of a head which bursts spontaneously out of the void, the excess of work effacing the traces of work. We no longer see how it has come nor from where it has come. The familiar face of Annette is still present, more present than ever, but detached, transfigured, so that it seems to us that we recognize the unknown which she is, that we sense without distinguishing it. A solitary apparition of an unknown Annette, that seems created by the sole power of a silent injunction.

Giacometti goes from known to unknown by stripping down, by progressive asceticism. He flays appearances and digs into reality until he renders visible the essence of their relationship, that is, the presence of something sacred. That sacredness whose nostalgia is expressed in all modern art, whose lack gives rise to undertakings as poignant as they are sterile. Giacometti drives it out of hiding and wakens it where it is hidden, in the depths of each new thing and each being. It is useless to dissociate the nymph from the forest and the siren from the wave. There is a sacredness only in the excess relationship between man and reality, in the impossible communication of the one with the whole, laceration of oneself and lacerating of the other, sole threshold and lightning flash, which the totalizing power of the creative act establishes.

TRANSLATED BY JOHN ASHBERY

IMPOSSIBLE REALITY

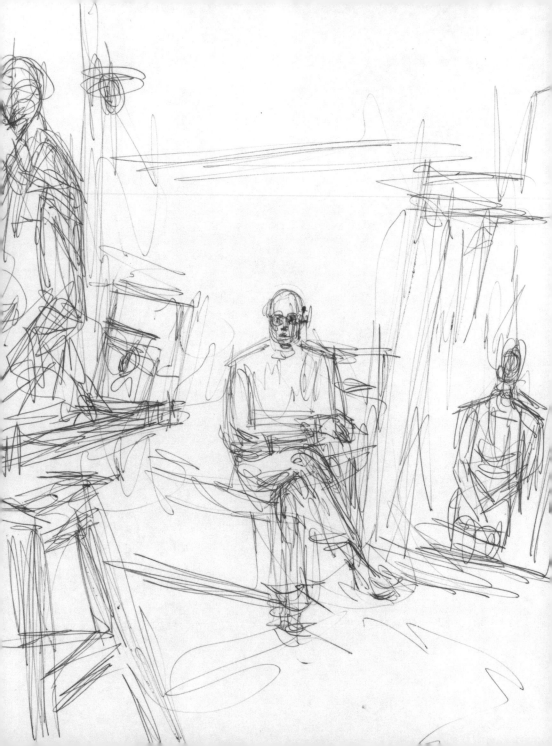

No artist of our time has interrogated reality with as much insistence, passion and amazement as Alberto Giacometti. Alone, against the current, he persisted in having models pose in the minuscule dusty studio where he worked for nearly forty years. Even during the period when he seemed to stray from his sole investigation, he still pursued it. In this pursuit, he burnt up his eyes and his life. In a moment by moment struggle, he devoted all his powers to it until they were exhausted, as if the meaning of his life, and the fate of Art, depended on a discovery which he judged to be at once ridiculous and impossible.

The pursuit of reality, of the totality of the real across any of its fragments, made it unnecessary to look farther than the space of the studio, than the head or the body of his brother, his wife or the habitual model, farther than the bottles on the table, the house across the way or a tree at the window. Each thing and each human being, untiringly questioned with that intensity that Giacometti puts into each gesture and each look, became the unknown, the pre-eminently unknown, and the object of an infinite approach, a renewed astonishment, an inexhaustible quest.

During the dozen or so years during which Giacometti, after unsuccessful efforts in Bourdelle's studio, seems to turn aside from reality, he doesn't truly

abandon it. With each of his returns to Stampa, stimulated by his father's workshop and example and far from the seething excitement of Paris, he sculpts and paints heads and busts, taking his relatives as models. In Paris, out of lover's spite or impatience, he turns his back on the real. He cannot undertake to sculpt a head without seeing it thin itself into a glossy slab without thickness, upon which the details of the face become simple low relief marks which hardly modulate the surface. Unable to render the whole and the details at the same time, he opts for the whole through stylizations of a troubling plastic perfection, in which he can integrate the lesson of the primitive arts and the discoveries of forerunners such as Laurens, Brancusi or Lipchitz. He assimilates the cubist reconstruction of space. He interrogates movement. He translates interior conflicts into dynamic oppositions of form and volume or nourishes the convulsive elements of his cages with his phantasms. The interior model has taken the place of concrete reality; the works of surrealist inspiration, sculptures or objects, are immediately caught and transcribed instead of being sought out in a period of questioning. These mysterious objects whose symbolic function has not stopped exerting its fascination—unlike so many others of that genre which are very quickly defused—seem to carry the precise enigmas of depth in a dazzling light. Cruel instruments, emblematic

*Translator's note: Dupin is referring to Giacometti's description of *Four Women on a Base*, which he describes as "Several nude women seen at the Sphinx [a brothel] while I was seated at the end of the room. The distance that separated us (the polished floor), which seemed impassable despite my desire to cross it, impressed me as much as the women did." Quoted in *Alberto Giacometti* (New York: The Museum of Modern Art, 1965), 60.

figures, coagulations of desire, delicately set traps, obsessional circuits, fragile constructions visited by death: they possess the same exactness, the same intensity of confrontation between outside and inside, as the works executed according to nature.

In subsequent periods each time Giacometti relinquishes models to work from memory, the recourse to the imaginary finds its bearings. In the style and the language that working from reality permitted him to discover and impose, he will create works more contrived from obsessional content, such as *Chariot* or *Figure in a Box* or *Falling Man* or also *The Cat* and *The Dog*—this last being also, by the sculptor's confession, a peculiar self-portrait. Circumstances or emotions or unusual visions inspire moreover *Head on a Rod*, that cry uttered before the death of another, or the gathering of individuals in *City Square*, *Glade*, and *The Forest*, or the enormous mass of the base on which four figurines are perched, transposing the polished floor which separates the visitor from the Sphinx's nude women.* All this portion of the work and the fragments of the human body erected in complete sculptures, such as The *Hand* or *The Leg*, echo the imaginary creations of the surrealist period and draw from the same source.

■

For Giacometti, to see reality is to open one's eyes to the world as if it just emerged for the first time. It is to invent a new gaze, a gaze relieved of and cleaned of the conventions which substitute concept for sensation and knowledge for seeing. This purification of the gaze, and the freshness of the world which responds to it, is obtained only at the price of a repeated and violent confrontation with reality, an uncertain and incessant passionate struggle which weaves between the protagonists a privileged bond, a bond alone capable of measuring their remoteness and of indicating their essential alterity.

For the reality that the eye perceives comes to light only at a distance, immersed in its space and surrounded by the void which cuts it off. The eye will have to dictate to the hand which draws—or paints, or shapes—the means of translating not only the plastic signs of the object, but simultaneously all that isolates it and closes it into its own space, welds it to depth and lets loom up only its separated and distant truth. The eye will consequently have to seize and restore its remoteness, its menace, its appeal, and all the complexity of the relation which links eye and object while leaving the latter inaccessible. The recreated image will have to unite the signs of a presence and the traces of a withdrawal.

From this paradoxical demand flows the particularity of works to different moments of experience, and to different types of approaches to reality. The distant vision of a human being, inseparable from the void which holds him captive, explains the stretching and elongation of the figure, the thinning out of the head, the massiveness of the foot or the exaggeration of the base from out of which, in taking root, the figure seems to emerge. It explains the chaotic and torn up surface of the sculptures, whose form is beset from all sides by an active emptiness which eats into it, rouses it, and breaks into it without rest.

In the drawings, the imprecision owed to approach and to distance dictates the multiplicity of lines which try to reveal each other and test each other, provoking resemblance without delimiting a contour or fixing the form; it controls the discontinuous stroke—the immensity of space; it summons the traces of erasure, opening gaps in the network of lines for the circulation of the emptiness and the seeping in of air.

And on canvas it is no less evident that gray and ochre, the very colors of remoteness, bathe, level out, and seep into the faces which emerge from a skein of lines and a multitude of brush-strokes, as if to manifest their distant authority only across an agitation of the depths.

■

All of Alberto Giacometti's art and the unity of his works proceeds more or less directly from his drawing, to which his painting and sculpture are subjugated if not integrated and intermingled. It is a drawing which combines the instant and duration, violence and repetition, aggression and infinite expectation. From the first strokes of the pencil the essential is found, but the initial discovery must immediately be fought against, contested, through the succession of lines which weave a sort of permeable skein from which the image emerges, living and free in expressed depth. The stroke unites the promptness of the attack with the repetition of the approach, so that reality, yielding to this double and contradictory appeal, might appear at the same time caught in its sleep and invigorated by the volubility of an amorous discourse attempting seduction from a distance.

On canvas with the finest brush, in clay with fingers and the point of a penknife, Giacometti still sketches, hurling the assault of his stroke, whose murderous impulse will dissolve itself into the interminable succession. Violence is absorbed by force of numbers, just as the monotony of re-inscription is exorcized by the acuteness of each attack.

The sculptures are indeed drawings in space. They avoid fullness of volume and smoothness of surface. They loathe massiveness and heaviness. Refusing

the slow approach of walking around them, they impose a frontal view. The accentuation of the base or of the foot of the figures has no other function except to permit and make manifest their gushing vigor, their lightness and their thinness in space. Giacometti seems to have successively devised every way of challenging the sculptural, of harrying it without abolishing it. In 1927, the heads become flattened out into the form of a blade, denying volume. A little after, the constructions open up, brighten, play with the void. And the objects of symbolic function of the following years again call into question the language of sculpture itself. After the return to models, the figures become minuscule, then exaggeratedly stretched; finally the mass, when it succeeds in being maintained, must suffer and communicate to the coldness of bronze the signs of a subterranean agitation by which the sculptural field is raised bit by bit.

The paintings, and especially the portraits, are like drawings in which the relative solidity of the support permits prolonging beyond all moderation the painter's dispute with his model. At the start of the process the image has appeared: the resembling portrait, signified space. It is only the preamble of a tighter and tighter pursuit over the course of which the face will experience complete eclipses and sudden resurgences. Thousands of strokes and lines —flung, retrieved, overlapped, effaced—will return with insistence—rapid,

violent, precise, hallucinated—and will surrender at their arbitrary interruption only the burning traces of an approach. Color which glows in the beginning very soon allows itself to be buried under gray, from where it diffuses only its glimmer, like embers smouldering under ashes. Portraits, still lifes or landscapes are less painted with color than designed with lines; gray, black or white lines, to which sometimes answer, now and then, through the gray filter, the red of a dress or the blue of a sky. Unified tint is proscribed, contrast between colors unknown. For Giacometti, to paint is to cast out innumerable sounding lines in such a way that none can immobilize the image. It is also to add to each stroke the one following which destroys it so as to obtain from their unanimous negation the solitary emergence of the face of the other.

Be it woman, studio or flower, the object seen and drawn is not separable from the void which engulfs and shields it. But it must still destroy the gaze which scrutinizes it to break into it alive, to render fecund the back of the eye, to plunge into the twisted roots of being so as to loom up alive again. This wounding of the gaze by the object and by the gaze of the other is an opening into the within, a fertilizing immersion of the image and its immediate projection onto the pedestal which receives it, precariously, without fixing it. This uncovering

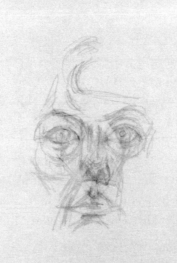

illuminates the relation between two beings who confront one another, the tension of two solitudes who contemplate one another over the void, throwing to one another the rickety bridge of their doubled, disconcerted gaze.

Whatever the chosen method of expression—and Giacometti passes indifferently and without rupture from paper to canvas or block of earth—the process is the same and the pursuit exclusionary, relentless and murderous, though it never ceases to be linked to the very practice of art. But it is pushed to the extreme of art's boundaries, often to the disappearance of the sculpture or the painting. Without going into detail about the immense hecatomb of work of all sorts and all periods or about the ruined space which might at times resemble his studio, Giacometti's insistence on making likeness loom up led in the course of work to an image's complete obliteration. How many times in the final portraits did the face vanish from the canvas? Invisible on the surface, it nevertheless remained alive, immersed in the gray inscribed filigree, and ready to come into sight with the next assault of eye and hand, to which it thus had to surrender, with which it thus had to tempt the impossible.

■

In the interminable dispute of the artist and his model, the only forces to which the artist can have recourse—so as not to abandon the advantage and let anything go of what he has torn away inch by inch from the unknown which repels him—are the very forces of destruction that his crazed enterprise liberates. Each gesture and look thus opens a gap in the opacity of appearances, in the screen of habit and convention. The old man and the statue must be broken together to let the truth of the unveiled figure communicate itself like an invisible fire to open and moulded clay. It is in cutting, in trimming without cease, that the human edifice will be able to rise, and the face appearing on the canvas will be reborn more intense, truer, for having been battered and obscured all the longer.

With an ogre's appetite, an insatiable desire, Alberto Giacometti threw himself on all which passed within range of his vision. He marveled before the acacias on the rue d'Alésia. The cup of coffee and the pedestal table astonished him. He had copied all the masterpieces of the history of art. He flung himself at newspapers, he thirsted for conversation with others, with friends and strangers, all being new, all being first comers. And if he devoured everything

with avidity, it wasn't so as to accumulate it and enrich himself, but to burn it up in assimilating it like food. In the same way he went to see and experience with his own eyes the discoveries and theories of the fauvists, the cubists, Dada, and surrealism, swallowing and dissipating their inheritance; he went out and then returned to his hiding place in the simple, in the inexhaustible reality which struck a pose before him. It attracts, stops, and always surprises him, remaining ungraspable. He desires it all the more as it escapes and leaves him to his hunger. He pursues it, shuts it into the studio. It has never been farther away nor more desirable. He wants it all, but he wants it as he sees it: free, distant, impregnable. He wants to recreate it in himself and outside of himself, and imagines himself both inside and outside of it. And he wants to fix in an image reality's close and familiar presence along with the interdiction of approaching it which makes it fascinating, indifferent, and sacred. In the final analysis, it can lead only to failure. But to a lucid and active failure which reopens the wound, the illusion, the desire, and returns the pursuit to the infinite.

It happened that Giacometti, by dint of excavating the appearance of what he sees and lives, by dint of skinning it of accident and of circumstance and of going to the very end of uncovering the real, touched the crux and touched death.

Space is petrified. The blooming flower is dust. The chair is as if suspended in the emptiness and silence of a tomb. And on the face of the female sitter suddenly the sockets grow hollow, the bones stand out, and the teeth of a corpse glimmer in the immobile light. Neither the tragedy of the walking man and the standing woman nor the suspense of beings and things in the paintings are strangers to this vision and this experience. But Giacometti doesn't stop here. Behind the hardness of cranium and bone, athwart the fire of the other's gaze, he uncovers and causes to burst forth the formidable energy of life and the forces of transgression from which he measures the inexhaustible strata at the bottom of other and of self. How not to feel in the figures that he erects and the faces that he paints, beyond the tragic fact and marks of ruinous erosion, the signs and power of the upheaval which detaches them from the floor or from the background, like figures of affirmation and awakening?

TRANSLATED BY BRIAN EVENSON

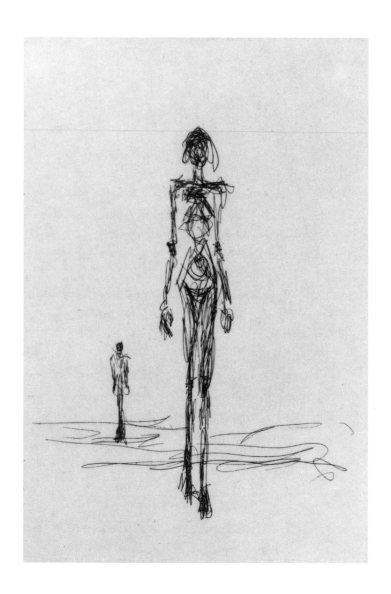

Frontispiece for L'Épervier, *by Jacques Dupin* Etching 1960

A WRITING WITHOUT END

Once more today, the first of the year, I try to write this text which has occupied me nearly exclusively for a week, but each day the difficulty of finding the words, of constructing sentences, of arriving at a whole becomes greater. Yesterday I sobbed with rage before the total deficiency of my means of expression, before those synoptic sentences, without weight and saying not at all what I want. Yet I must try to have done with it. ALBERTO GIACOMETTI

To decide to write for others, for someone, involves from the first words inscribed, like putting on a mask, the measuring of a distance, the acceptance of the rules of the game. A fact which disturbs and dumbfounds the writer-not-author that Giacometti believes himself to be and which, in a certain sense, he is. But becoming conscious of the impossibility of writing is the threshold that must be crossed like a rite of passage, and the test of the preliminary pages which flush out and give rise to the author. In fact, in the text that I just cited, consecrated to sculptor Henri Laurens, beyond the established fact of impotence and the sobs of rage flow words and images and the thread of an intention which in meandering draws near to the truth of the model, to the truth which separates and unites the two sculptors, the tenderness and the bitterness of a resemblance. Giacometti discovers very quickly that writing, in working itself out, in bringing itself onto the page, in gaining by degrees and in besieging an unknown territory, eats away like acid the codes and interdictions which detain it, opens the unhoped-for space that is its own, invents its rhythm and its laws, and liberates the breath and the steps of the author despite himself. Giacometti puts the mask on and tears it off in following his path, in joining an uncertain contest against himself, in hollowing out a permeable opac-

ity, in jostling a sleeping corpse. The texts he gives us to read are the scattered fragments, the truthful moments of their rash destruction . . .

As in the drawings, the paintings and the sculptures, the writing of Alberto Giacometti is never fixed nor assured, never linear nor peremptory. It rushes forth, hesitates, bifurcates, erases itself, returns. It looks for a support, a springboard, so as to object to them, to rid itself of them. It progresses by bounds, breaks, retouchings, advances and recoilings, sallies and collapses. Its lively, rapid course is interrupted by doubt, scruple, the suspension point on the other side of the void. It is identical to the line in his drawings. The line which is fluid, light, hasty, but lost, recaptured, rubbed out, multiplied, adventurous: a line awakening open space which stirs up an essential digression . . . A word, a line, which tries to understand itself, interrogate itself, in questioning the near and the far, in combining the aimed shot and the blind penetration of a fog. Which retains of the night journey only imponderable traces and a shining bundle of sharp strokes among the debris of a dark space. The discontinuity which, for Giacometti, is the method of approaching and capturing the real, would also perhaps be the breathing pattern, the movement itself, of an unrestrained writing.

■

What gives to the written texts, as to the reported remarks, this naturalness, this roughness, this emotion and this conspicuousness, is not due to the art of writing but first to the art of living or rather of burning up one's life, to the intensity of a life entirely possessed by the search for its truth. Desire, work, adventure—life is a marvelous adventure— push and steer the works of Giacometti the writer. Every day, every minute, even if he doesn't write he speaks or mutters, or he grumbles. He needs words, he needs the murmur of language to whet his cannibal hunger, so as to bite living reality, so as to expose himself and to call himself into question, to strip himself bare, devour his prize—and to continue the journey . . .

He needs to measure and illuminate with words the distance of things and of beings—the visible and affective distance, the physical and metaphysical distance—the unknown of all reality, its reason to live, and the unobtainable end of a relentless investigation. Giacometti writes like he looks at things, walks in the street, smokes a cigarette or tirelessly manipulates clay for a nude . . . Without a single care, a single literary pretense. Listening exclusively to the pestering truth which mistrusts and flees him, which makes him walk without rest, which forces him to push farther . . . He writes for this unknown blindman who resembles him, writing being always on the heels of life, on the heels

of the surprising vision of an ephemeral world opening itself only in the flash of a stolen moment—yet one must be ready and never stop waiting for it … Unknown, marvelous: so appear to his eyes the glass on the pedestal table, the acacias of rue d'Alésia, the look of Diego posing … Life is fantastic in its unveiled transparency, in the quasi-sacred silence suddenly revealed in obtaining it: life and death, shadow and prey confused, the object of desire holding only by a thread, suspended in the void, stretched over the abyss …

In the writings, in the painted, sculpted and drawn work, the consciousness of gain and conquest is indissociable from the feeling of failure. The advances and retreats are together firings and counterfirings, markers of errancy and breach. Light, the absolute which provides stimulus and tension, flashes from afar, from the depths of childhood and the future. Its radiance weakens only so as to grow stronger, to sharpen itself. Its transparency along a horizon which always withdraws, which falls into decay and rekindles itself according to the moment and the intensity of desire, stays the only source of lucid energy directing each gesture and projecting each word …

Gestures, words: wasted without being counted, with a senseless extravagance, a juvenile fury, without ceasing to emit, radiate, and hold the threads of

an ambiguous communication. A volubility which is never accretion or accumulation but on the contrary a means of canceling or subtracting what each stroke may have that is excessive or incongruous, assured. A flow which arises from innumerable squandered and shattered impulses, opening fissures to attract, seduce, and introduce the unknown, and to substitute the splendor of space for the flight of time inherent to writing, to life. Gestures and words crowd and crystalize before the void, the silence which attests to them and vindicates them. The counted works and the registered texts are only the emerged and communicable lesser part of an immense expenditure of gestures and words forever lost, disappeared, burnt up, all as precious, significant, and revelatory as those which are left for us to read or see . . .

With the exception of the *Notebooks*—which are still tied to a moment, a place, an incident of life—all the writings or transcribed remarks of Alberto Giacometti depend more or less on circumstance. They are written as, or in connection with, responses to questions, commissions, invitations of friends . . . But he declines many of these, and his rejoinders—always given with good grace and in taking pleasure from the task—are crafty enough despite himself to disarm traps, divert arrows, outrun tiresome pursuers, and above all de-

fend terrain like a fighting bull. Whether discussing Laurens or Callot, Braque or Derain, a childhood memory, his last sculpture, Italy or the Car Expo, he never ceases to return to the only questions which obsess him. And he integrates the event, adapts it, really considers it only in the light of the studio. All events he claims become evoked and confronted reality, the remaining traces, the burnt marks of a crossing and a collision, but also the traces of a projection of self and the sketching of a self-portrait.

The link between event and self-portrait is not accidental, but it is more manifest and more striking when Giacometti is painting or sculpting. That which stops us and surrounds us, the outside, is for Giacometti a more distant mirror, harder to penetrate and more fertile in the end than is the iciness of a mirror which reflects too quickly and too soon. Near and polished, the mirror which unresistingly delivers an inverted image is unreliable. Roundabout and overgrown paths enrich the pursuit and gratify the effort. Giacometti is fond of the errancy of an irregular path and prefers a tumultuous network of lines to the cleanness of a vector. The knowledge and the recognition of self—and of the other—must depart from the farthest point to attain and arouse what is closest. And Alberto Giacometti, it is clear, has made up his mind to go, to lose

himself, to march blindfolded to clarity, holding within sight very far away in the beam of his miner's lamp the point of no return and the light which destroys ...

The writings show the place held in Alberto Giacometti's life by encounters, friendship, love, dreams, objects and landscapes, the street, the brothel, the museum. He goes from one to another and associates them, combines them, confuses them. He stumbles, branches off, recoils, rushes ... In writing, in copying, he doesn't stop considering the art of the past. He enthuses and breaks away. He becomes enamoured of Tintoretto in Venice and betrays him for Giotto in Padua. He passes through, and feeds himself on Lascaux, on Goudéa, on the New Hebrides islands, on Cimabue of Assisi, on Cezanne and on Matisse, and on the "Crouching Scribe" in the Louvre, Egyptian art being his essential reference. However, the masterpieces which fascinate him and which he untiringly copies are eclipsed by young women seen in the street or the face of a visitor in the Louvre. Before familiar reality, inexhaustible to his eyes, Giacometti writes—neither scribe, nor crouching, but a man who walks in hurrying his steps, impatient, ravenous, going toward the frenzied discovery of

world and self, of self and of other ... No need of India nor of China; the proximity of a tree, a footstool, a glass is sufficient for him. His pessimism and his tragic vision project into the absolute only the experience of the void and the bar of a horizon which is inaccessible but which it would be crazy to give up trying to reach. The confusion, the established fact of failure, and the truth of the abyss which darkens the paintings and makes emerge at a distance the head and nudes modeled in the void, have less discouraged Giacometti than they have stimulated and armed him, if not fortified until the end his desire to vanquish, advance, and draw near again ...

Scraps of an intermittent diary, conversation caught in mid-flight, statements, projects, reflections on work and poetic wanderings, word games and spurts of images, the *Notebooks* kept by Alberto Giacometti address themselves to no one, not even to their author, who neither corrected them nor probably reread them. Notebooks scrawled any which way, on the terrace of a café, at a restaurant table, wherever ... A handwriting often hardly decipherable, at once effervescent and derelict, ascending to the origin, to his early impulses. Without any other justification than writing for writing's sake, filling in the gaps and

* Translator's note: The word *calepin*, a French word of Italian origin, refers generally to note-
books and more specifically to pocket notebooks, though Dupin argues that it is a more inti-
mate term than *cahier* which refers to both sorts of notebooks as well.

the fissures, elucidating the disorder, taking a notch out of the void when the
threat of blindness worsens around onself. And to seize the instant which ig-
nites that to which he connects for ideas, images, memories, judgments, and
dreams . . .

Notebooks or, better, *calepins*, objects that are more intimate, nearer to the
body and in addition a word taken from Italian,* G.'s native language and the
language of his mother, a language to which he returned each evening to call
her on the telephone. A notebook deformed by the pocket and which has suf-
fered the insults of work and of the studio. A notebook which has been mis-
treated, blemished, torn, stained with coffee, burnt with cigarettes—and jot-
ted in with haste, without concern for punctuation, pauses, page positioning,
readability—as uncertain and problematic for the transcriber's eye as ancient
manuscripts exhumed from archeological excavations . . . Except for that, they
are the most lively and direct writing, the closest to him and to us . . .

These precious and fragile notebooks, careless but revelatory, charged with ob-
scurity and meaning, how many are there? It seems that they were always

there in his pocket, within reach of a pencil, to gather the most fleeting and most stubborn of thoughts. Those which we have touched, examined cautiously, deciphered with difficulty, are they the only ones? Do others exist? In whose hands? Not to know is also to be in harmony with Giacometti's work, whose essential incompleteness is the true lesson and the proper achievement.... For the *Notebooks* are less supports than targets, braziers, fiery furnaces stirred up in confusion or mad hope. The shots taken at the center of the target, the arabesques in the margins: appeals, counterappeals. Adjustments, exposures, the exuberance of quick jaunts on open waters.

They come out of the urgency to write and from the sectioning of time. They are there to mark—like a knife notching a stick—the passing of hours and that which the unknown conceals, what it tries to subtract in withdrawing itself. They are the exasperated, sputtering exorcism of the constraints of the day, of joined battles, lost engagements, heart failures ...

The uncontrolled and unguarded writing of the *Notebooks* equally sets free fragments of dream or notes on work in progress, or the fragments of phrases or of poems which stem out of automatic writing, non-sense, counting rhymes, word games, the "glossary" of Michel Leiris, and the belchings of Artaud.

Portrait of Michel Leiris Etching 1961 45 × 31.5 cm

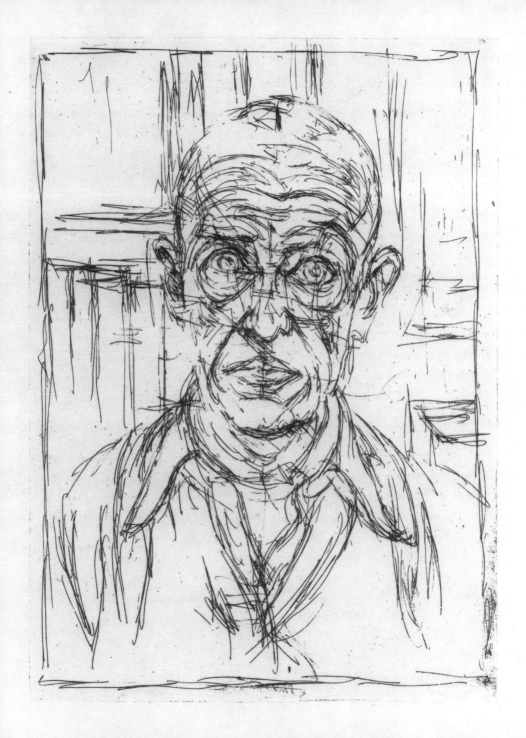

A language at liberty, nascent, which isn't aware of barriers and which haphazardly flashes with lucky success. Without laws, without rules, without readers. And fortune is seized in mid-flight, incongruous lucky discoveries are rediscoveries, the bringing to light of deeply haunting memories lurking behind the eye. An obsessional jumble consigned to a beautiful disorder conjoined to dance, a savage dance, a pencilled trampling ... As if the sensation of the void and the fear of and attraction for the unknown, exercise their fascination and could, in the hallucinated hours which follow exhausting work, arise and crystalize into this sort of stammering, tattered and lacerated music ...

In the pocket notebook, a sentence is never begun nor finished nor locked down. But it is grafted onto life, and onto the life of the other. As if in a state of weightlessness, it emerges from nothing, from a torn fog, from an elusive murmur, and floats, and spills out beyond the void, the void which carries it and radiates it ... It releases wavering woods, bodies asleep on the sea. The sea, origin and perpetuator of the immense blind respiration from which these texts seem cast and fashioned. ... Thrown out and sparkling, like divergent and antagonistic glints thrown by countless facets from a single rock crystal ... Facets, sensa-

tions, thoughts from which the scattered flow and the refracted images loom up from the same crux, leading back to the same questioning source . . .

Splinters of a life, splinters and shavings of a life, rapid notes without forethought or supervision, careless sketch of a man, of a creator, in a hurry to see, to understand, to walk—to devour the world, to seize reality . . . His days, his rebellion, his enjoyment and voraciousness, his anxiety and reserve, haunt and rouse each leaf of those untouchable notebooks . . . What is written is dashed off in the moment, cut from life without recoiling or repenting. A scattering of feelings and visions, a spinning out of dreams and evocations of childhood, a collision of words and images which turn into poems, ludic outbursts and shrieks—augmented by quid pro quos hybridized from two languages which cloud themselves over or catapult one another. Augmented particularly by a sculptor's vision: with each turn of phrase comes a notion of space, of dimensions, of distance, of proportion, the falling due of the plumb line, the plotting of the horizon, precise oppositions and moving antagonisms—the light and dark mass of space and a thousand recurrent indications which belong to sculpture. A powerful and hallucinatory impregnation—fatal when one touches

bottom—saturates the writings of the *Notebooks*. As if they draw their powers and their charms from the strata of a gold-bearing subsoil. Or from a walled-up cell. Or from gardens suspended in the void ... Without corrupting the listening-place, without blunting the view ...

If one ascends to the surface, returning to the appearance of the *Notebooks*, one cannot fail to see that they are an exact replica of the sculptor's studio. Their disorder and poorness, their stains and their lacerations, the feeling of abandonment and precariousness that they give, seem like a double of the studio such as we know it. Its dilapidation, litter, confinement, dust, gray light ... The same graffiti on the leprous walls and the soiled pages, the same desired, significant tininess ... The same intimacy, the same exchange between body and tool, and the same paradoxical and murderous contest between proximity and immensity, the proximity of the object, the immensity of space ... The same extension of the hand which trembles, which doesn't tremble, which gains ground, which grows bold ... The notebook will be like another studio, portable and mobile, slid into the pocket, held in the hand ...

∎

In the interviews—as in the published writings and the *Notebooks*—we recognize the voice of Alberto Giacometti, the same voice, the same obsessions. An inflexible exigency, a living intensity which goes after each phrase as if it dominated each gesture of the sculptor, the painter, the sketcher. The differences inherent to the means of expression grow blurred and merge in the intake of a unique truth which blazes its trail of confidence in provocation and of recognition in destruction until the limit is attained where the flow stops, where the man falls asleep from exhaustion, where the work pursues a subterranean course . . . Because it doesn't understand its end, doesn't imagine the triumph of conclusion or of completion, the phrase is never closed off, nor the bust of Annette finished.

The interviews, the extracts that we have taken out of them, are not writings in the strictest sense, but transcriptions of remarks that Alberto Giacometti reviewed, corrected and approved. They accompany, clarify and define his process and his thought. Their formulation is very close to, and often comparable to, a number of writings which take the movement of a conversation and pick up the spoken style. The same effects of language reoccur, the same turns, the same touch and the same inflection. It is impossible for those who

knew him not to recognize the quality of his voice, its upward lift, his accent, his delivery, his mountain roughness, his artless ferocity. His fumbling and impassioned search for word and meaning . . .

The interview is the greeting of and opening up to the other, the privileged hour of conversation, of debate and affability and of the pleasure of exchange . . . Contrary to what one has said and written of his savage and entrenched character and his difficult manner, Giacometti was an open man, eager to welcome and anxious to discuss. Conversation, which he sought more than anything and which did not hinder him from working, was the better part of his life. He was driven by an irresistible need to communicate, to listen and answer back, to think out loud—and gruffly—with someone else and for the sake of someone else. Open and provocative, he pushed the idea which tortured him to absurdity and paradox. With a distant humor, the one-upmanship of split personality, the taste for destruction, a scrupulous correctness of thought . . . His subject matter stakes out a discontinuous path, sawtooth style, dominated by a fixed idea which insistently returns only to bring each time correctives, additions, developments and illuminations which seem to him necessary to sharpen his blade and secure his power of insight. Words crowd and multiply

themselves to infinity, like the lines of the drawings, the gestures of modeling or the manner of painting, to grasp more closely the resemblance to the real . . .

Thus a need to speak, tell, see, and be heard. . . . The unremittingness of working with material—with dust, the void, and light—having to accompany itself with the unremittingness of conversation, the overture to the other from wherever he comes from and wherever he is going. Even if by the force of things and the orientation of desire the ideas and the phantasms return which give the work in development its backbone and its movement—as for sculpture, its armature and its infinite modeling—an exchange of words, and its dispersion in its own flux . . .

In his published interviews as in daily conversation Giacometti doesn't take leave of himself, never loses sight of himself, his demons and his chimeras don't leave him and don't let him become unhinged . . . He is listening in, he and they are listening in, to the confused noise encircling them or to an admitted partner . . . Here as in the approach to work it is necessary to find the proper distance, a space of complicity which liberates words . . . A trusting and privileged connection which ties into, with less intensity, the strange liaison of artist and model, still never truly elucidated.

■

Each portion of this frank book makes evident the rivalry and the union of three ruling obsessions which govern Albert Giacometti's work and life, whose energy and radiance lift them up, pull them, orient them, and qualify them. Three absolute origins—childhood, woman, and death—never completely linked, never truly disentangled . . .

The book is steeped in the freshness of childhood, its music and its cruelty. Mountains, a line of peaks hiding the sun, giving value to light. Shelter under trees and in the cavities of rocks. The studio of his father, the painter. The ambiguous threads of dreams and games. The short-lived and stupendous apprenticeship of pencil, color, and earth. The fleshy attachment to his mother, guardian shade, keeper and pillar until the end . . .

Woman, woman standing, looming. The sitter on the stool, friends before the window, the distant forbidden girls of the Sphinx, enlarged by the brilliance of a polished floor . . . The woman whose throat he cuts in dream, and the same woman feared when met and passed in the street. The same, and the other, and the only, the fascination she exercises, the distance she illuminates, the desire to devour and to transgress which she stirs up, the unknown with which her body and gaze become identified . . .

Death is the essence, less the shadow than the light which cuts up and tears to shreds, and less the light which bathes the silhouette of the living man or woman, than the transparency which shows through bare flesh. There are chance encounters, unvarnished tales which make death up, from which emanate a fragrance, an obsessional style, and it is in the sculpted work of head-skulls and open mouths, and of screams modeled in plaster, and that sort of light which desires and which repels ... But there is sometimes a lunar transparency which lights the bones in the flesh tint of a woman's face or in her immobile height. Death, an immortal, a perverse ingenue, a servant, a hussy, a priestess of Apollo without her tripod ... And in its infiltration of the living, here, there, in front of one, at each moment, in the bar of and the darkness of the horizon, from which light finally ascends ...

The void, the breach, the dark space, the air-pocket ... The writings and remarks of Alberto Giacometti take form and life only through the void which carries them, which justifies them violently. By violation, acquaintance, the intake of breath ... Against the distant world, against the imposed structure, the sight by transparency of the skeleton, the skull and the hollowed socket—

the void is the force of life, the agitation in everyone, the establishing principle ... Gnawing at ancient and tenacious opacities, it opens space to the inrush of the outside and of the future, to the emancipation of origins, to light ... Negativity at work inside of form and vision, syncopation in rhythm and tear in weft, it exposes and brings to life, it levels and fecundates broken material, greedy substance ... The active presence of the void Giacometti called it, named it, repeated it word by word and line by line, as if it, at each instant suffered and enjoyed, alone gave a meaning to his vision of things and to the music of time ... It is the acid which eats into the sculpted figures and the rising force which makes them spring up from their base. It is what gives to each written phrase its tension, respiration, doubtful vigor and movement of infinite opening ...

TRANSLATED BY BRIAN EVENSON